Hanif Kureishi grew up in Kent a
King's College London. His novels include *The Buddha of Suburbia*, which won the Whitbread Prize for Best First Novel, *The Black Album*, *Intimacy*, *The Last Word* and *The Nothing*. His screenplays include *My Beautiful Laundrette*, which received an Oscar nomination for Best Screenplay, *Sammy and Rosie Get Laid* and *Le Week-End*. He has also published several collections of short stories. Kureishi has been awarded the Chevalier de l'Ordre des Arts et des Lettres and the PEN/Pinter Prize and is a Commander of the Order of the British Empire. His work has been translated into thirty-six languages. He is Professor of Creative Writing at Kingston University.

Further praise for *What Happened?*:

'As well as plays and film scripts, novels and short stories, Kureishi has regularly published non-fiction: memoirs, diaries, columns. In certain moods, when swept away by his warm, sturdy, easy-going voice, it can be possible to feel that this sideline – this third or fourth or fifth career – represents Kureishi at his best . . . Modesty of theme proves a good match for Kureishi's unfussy intelligence and powers of compression. He also shows a gift for maximising the potential of almost any subject.' Leo Robson, *Daily Telegraph*

'Don't miss Kureishi's funny, fond account of the former Faber boss Matthew Evans. Or the memoir piece recalling how, as a mixed-race child, Kureishi loved watching Peter Sellers in brownface – because his comic Indian character reminded him of his own father.' Claire Lowdon, *Sunday Times*

WHAT HAPPENED?

Stories and Essays

HANIF KUREISHI

faber

First published in 2019
by Faber and Faber Limited
Bloomsbury House
74–77 Great Russell Street
London WC1B 3DA
This paperback edition published in 2021

Typeset by Faber & Faber Limited
Printed and bound by CPI Group (UK) Ltd, Croydon CR0 4YY

A CIP record for this book
is available from the British Library

ISBN 978-0-571-35206-7

FSC
www.fsc.org
MIX
Paper from
responsible sources
FSC® C020471

2 4 6 8 10 9 7 5 3 1

To Isabella

Contents

Introduction

Writing has been my life: I decided as a teenager that story-telling was what I wanted to do, and I was determined that it would be how I earned my living, however paltry that might be. I did attempt other things – offices, theatres, bookshops – but I am naturally ungregarious, bad at taking orders and lazy. I try never to leave the house before 9 a.m., and, if possible, 9 p.m. I wanted to choose my boredom. Keith Richards wasn't working in an office; Hendrix wasn't filing.

There's a lot to be said for inactivity. Being alone in a room for a long time, with what Conrad calls 'liberty of imagination' – as well as music, coffee and pens and good paper – suits me. You can pace your study, talk to yourself and nap when you like, and how many jobs can you say that about? I enjoy writing as much now as when I began, if not more. I usually start as soon as I wake up, like most of the writers I know. Some of it comes easily; most of it slowly, and I go over it until I think I'm going blind. Naturally, there are periods when you can't write a thing and become convinced it's all over. There are other times when you're full of it. This seems to be beyond one's control.

Being lazy doesn't mean I'm not nosy and don't wallow in gossip, which is always a useful source of stories. One of my desks overlooks the street, and this being a great city of events, there's much to see, particularly after I bought the binoculars.

While London has been an exciting place to live, Britain was a relatively quiet and cosy place for most of my life. Yet there have been revolutions in finance, music and culture, in the way race and homosexuality are seen, and particularly in terms of the place of women, who were, like my mother, when I was a child at the end of the 1950s, mostly housewives, and would describe themselves as such. When women began to bust out of their roles, it altered everything for men. We had to change the way we saw ourselves; our relationships with women became more difficult, expansive and much improved. To write about human beings is to think about gender, race and class. Everyone is standing somewhere.

Many of us semi-delinquent kids in the suburbs believed we didn't fit in. To feel that one will never quite belong to any creed, religion, class or country is an opportunity to see things from the side or, as E. M. Forster puts it, from 'an oblique angle'. I have often used autobiography – the experience of being mixed-race – as the starting point of a story. Beginning with the enigma of myself, of how others saw me, and with something I felt and wanted to express, I moved out into the social and political world: the end

of empire, the early years of my family's life in Britain, through multiculturalism and the re-emergence of fascism in Europe, with Islam as the organising principle.

From an early age I was fascinated by writers' daily activities and biographies, by how much they wrote and how they made a living; and, often, how they didn't.

There are now shelves of books about what is called 'creative' writing, as if there's any other sort, and I enjoy reading those too. Apart from the fact that the plot is usually the least interesting part of any story, few of these guides mention the fact that frustration is the medium of any kind of achievement. In writing – as, I guess, in every other art form – frustration, the sense of being eternally stuck, of living in an endless interval, is essential and what writers live with all day. Frustration is an engine, a stimulus, an opportunity and a postponement, and you can use it and work with it, making doubt and anguish pleasurable. The trick is not to exit frustration prematurely: it is a generative, if not agitating, space, where you have to wait and imagine. The satisfaction of making a breakthrough, of actually finishing something, means little compared to the pleasure of striving. Finishing only means you have to begin again.

I've been fortunate to have spent time with good writing teachers. Some editors, and most of the directors who have produced my work, have taught me about cutting and organisation, the craft of writing: order, rhythm

and pace. And the use of deferral: suspense – the art of withholding.

A good place to study and learn this is in the theatre, where, literally, you can hear the audience responding to the language. Most good writers know how they want their work to look and sound – particularly if spoken by actors – but it's never stupid to hear from others. This can make the process more dialectical and collaborative than it can seem at first. And the collaborations I've been part of, in theatre, cinema, dance and with musicians, have pushed me to do work I could never have contemplated alone.

Since I was fortunate enough to work at the Royal Court Theatre in my late teens, I've been a teacher, and I've always enjoyed talking about writing and stories, and how writers might trap the reader, seduce and play games with them, and generally mess them around while giving them the time of their lives. This is responsible and socially useful work. After all, most of humanity, almost every day, is attending to some form of story or another, created by a writer.

I've never had a beef with students and their desire to say something about themselves and the world; I am usually curious to read their work and receive what they have to say. Witnessing a spark of originality, a unique way of expressing something, particularly if you yourself have encouraged it, is magical. As Chekhov says of

the writer's work, 'My business is merely to be talented.' The gift of talent is, fortunately, mysterious and unevenly distributed. It can be encouraged and developed but not inherited or implanted.

I have had some disagreements with the institutions, which appear to be mostly concerned with gathering money, rather than with the improvement of their charges. However, the decline of the novel as the central form for the exploration of human beings, and the development of new media – the long-form television show, podcasts, indie movies – have created more opportunities for writers of all ages. Several writer friends, in their late seventies, who work with the energy of people twenty years younger, have not found themselves redundant, but are as in demand and busy with commissions and projects as they've ever been. I've never met a retired writer. Getting older means you have more to say and are less inhibited. Once the kids have grown up, you have more time, and what else would you do all day?

A significant alteration in the writer's ecosystem has been the rise in literary festivals and events. It was rare when I was younger, at least in Britain, for writers to give readings, but it was a hugely exciting thrill to see James Baldwin, Gore Vidal or Norman Mailer being ornery and political on Sunday-night television, showing those of us who were isolated in the suburbs that writers and

thinkers are not an esoteric bauble, but essential to the intellectual life of the country. Now festivals are ubiquitous, some drawing vast crowds, which is a good thing for literature, if a little nerve-wracking for scribblers who spend a lot of their lives in the dark, often becoming writers because they find it hard talking to other people, let alone addressing a multitude.

The essay is an enjoyable, intimate and flexible form which is relatively quick to write and should be easy to read. A few of the pieces collected here were written for specific occasions, like the opportunity to walk around my west London neighbourhood and describe what I saw. Others because I wanted to say something about pleasures: drugs, literature, pop. If you don't know anything until afterwards, 'What happened?' is the writer's fundamental question, where one starts to seek the words which might surround the baffling and exciting mess of existence. We are what has disturbed us, and we return repeatedly to it, with some hope of mastery at last, saying the unsayable, turning accidents into stories. Although coherence is an illusion, it is the striving and failure which makes art. Almost all of my writing in various shapes has occurred because I had an idea or set of characters who wouldn't leave me alone, and I absolutely needed to find the words to say it, whatever that *it* might be. This is how I've mostly proceeded, following my curiosity. There is seeing first, which is indistinct; and then saying, which must be clearer.

Introduction

There is, then, an odd thing about writing: however long you've been doing it – and most of us find it necessary to wonder daily why we bother at all – you still have to start afresh each time, as if you've never done it before, which provides a new opportunity for frustration and hope.

Birdy Num-Num

Here's an odd thing. As a mixed-race kid growing up in the south London suburbs in the 1960s, I liked any film starring Peter Sellers, particularly *I'm All Right Jack, Dr Strangelove* and *The Pink Panther*. But my two favourites were *The Millionairess* and *The Party*, in which Peter Sellers played, respectively, an Indian doctor and a failing Indian actor.

In both films Sellers, in brownface, performs a comic Indian accent, along with a good deal of Indian head-waggling, exotic hand-gesturing and babyish nonsense talk. He likes to mutter, for instance, 'Birdy num-num,' a phrase I still enjoy replicating while putting on my shoes. And I'm even fond of singing 'Goodness, Gracious Me', the promotional song from *The Millionairess,* produced by the peerless George Martin. So, at the end of the 1960s, my sister, mother and I came to adore Sellers's Indian character, repeating his lines aloud as we went about our business in the house, because we liked to think he resembled Dad.

My father, an Indian Muslim who had come to Britain at the end of the 1940s to study law, was, in his accent

and choice of words, upper-middle-class Indian. As a child and young man he'd spoken mostly English, since his father – who liked the British but hated colonialism – was a colonel and doctor in the British Army. However, we didn't think of Dad's accent as Indian; for us it was a mangling of English. There was a standard, southern, London accent, and he didn't have one. He was a mimic, but a bad one, as all colonial subjects would have to be. If the white Englishman was the benchmark of humanity, almost everyone else would necessarily be a failed approximation. Dad could never get it right. Indians were, therefore, inevitably comic. And because my father, as a father, was powerful and paternal, our teasing shrank him a little.

Dad was also sweet, funny and gentle, but not wildly dissimilar – in some moods – to the hapless characters Sellers plays. My sister and I had been born in Britain after all. We knew how things went and Dad didn't. As I wrote in *The Buddha of Suburbia*, 'He stumbled around the area as if he'd just got off the boat.' If my father's way of misunderstanding hadn't been comic, it might have become moving or even upsetting.

When I got older, my younger self embarrassed me. I vowed not to look at those movies again. Foolishly, I'd allowed myself to be tricked into loving a grotesque construct, a racist reduction of my father and fellow countryman to a cretinous caricature, and I'd be advised to

backtrack on my choices. Yet recently, re-watching the films, when I stopped weeping my views changed once more, and I want to think about what I liked in them.

My mother had married what was then called 'a coloured man' in London in the early 1950s, at a time when one fear in the West was of unauthorised boundary crossing, or miscegenation. It was with miscegenation that the terror of racial difference was placed. Men of colour could not and should not be desired by white women, nor should they breed with them. People of whatever colour could only go with others of similar colour; otherwise some idea of purity would be defiled. Racial separation thus ensured the world remained uniform and stable. That way the most important thing – white wealth, privilege and power – would be sustained. Nor was the crime of 'crossing' trivial. We should not forget that Hollywood's Production Code banned miscegenation from the American cinema for thirty years.

As children of mixed-race background, though not particularly dark-skinned (I'd describe myself as 'brownish'), we were subject to some curiosity. People were worried for us because, surely, being neither one thing nor the other, we'd never have an ethnic home. We mongrels would linger for ever in some kind of racial limbo. It would be a long time before we could enjoy being different.

It is with this in mind that we should look at *The Millionairess*, while not forgetting that Sidney Webb,

a close friend of Bernard Shaw – the author of *The Millionairess* – and a supporter of eugenics, warned that England was threatened by 'race deterioration'. I was surprised to read that Shaw himself wrote, 'The only fundamental and possible socialism is the socialisation of the selective breeding of man.'

Despite this, we should consider how few mixed relationships were shown on screen. Anthony Asquith's movie, made in 1958, was adapted by Wolf Mankowitz from Shaw's 1936 play, in which the male lead is Egyptian. In Asquith's version, a divine Sophia Loren – an aristocratic, rich Italian called Epifania Parerga – falls in love, while attempting suicide, with an Indian Muslim doctor who, at first, sees her as nothing but a nuisance.

I must have seen this on television, and I don't recall many people of colour appearing in the movies I saw at the cinema with my father, except for *Zulu* and *Lawrence of Arabia*. This was also a time when black film-makers were virtually invisible. The Sellers character, Dr Ahmed el Kabir, is not only a Muslim man of colour and voluntarily poor, he is cultured, educated and dedicated to helping the indigent and racially marginalised. Most natives in most movies, of course, had always been shown as thieves, servants or whores, or as effeminate Asiatics. We were always considered dodgy. Roger Scruton writes in *England: An Elegy*, 'The empire was acquired by roving

adventurers and merchants, trading with natives whom they could not or would not trust . . .'

We were thrilled, then, that the movie would include no covert fantasy of coloured men raping white women, a trope which seemed to me to be almost compulsory since *A Passage to India* and *The Raj Quartet*. And *The Millionairess* does, in fact, have a nice Hollywood ending, with the mixed-race couple together, enjoying one another.

While *The Millionairess* looks creaky and silly in places, but is saved by the performances of the leading couple, *The Party* is a lovely film. Sellers, obviously a great comic actor, is at the peak of his mad inventiveness, and Blake Edwards is a brilliant director of physical comedy. Composed of a series of perfectly judged vignettes – a carousel of increasingly bizarre incidents – the movie becomes riotously anarchic as Sellers's innocent Indian creates, inadvertently, total chaos at the house of film producer General Clutterbuck, to whose party he is mistakenly invited after blowing up his movie set.

At the beginning of the movie, Sellers's character, Hrundi, is shown playing the sitar, reminding us that at this time – it is the year when *Sgt Pepper* was being played in every shop, party and house you visited – Indians were supposed to possess innate wisdom, beyond the new materialism of this dawning vulgar age in the West. When, soon after, Hrundi attends the smart Hollywood

party, it isn't difficult to identify with his apprehension. Don't we all feel, when going to a party, that we are about to lose our shoe in a water feature and will spend the next hour on one leg?

Yet he is even more out of place than we would be, and unnerving in his strange, formal politeness. 'Do you speak Hindustani?' he asks strangers, who are baffled by his question. 'Could you ever understand me?' would be a translation. 'Do you want to?'

The Party was released in 1968 and I'm surprised at my enthusiasm for it at the time, since this was also the year of Enoch Powell's grand guignol 'Rivers of Blood' speech. If my father and other Asian incomers seemed wounded in Britain, vulnerable, liable to abuse, looked down on, patronised, tolerant of insults, racism made me want to be tougher than my father. My generation would rather resemble the Black Panthers than the Pink Panther. We knew we didn't have to cringe and take it, for this was the era of Eldridge Cleaver, Stokely Carmichael and Angela Davis. These blacks were so sexy with their guns and open shirts and attitude, and I'd been mesmerised by the black-gloved salute of Tommie Smith and John Carlos at the 1968 Mexico Olympics.

There's nothing macho about Hrundi. He's a different sort of heterosexual leading man to those usually preferred in the American cinema. When, at the party, he meets one of his heroes – a tough but charming cowboy

with an iron handshake and a movie reputation for shooting Red Indians – Hrundi is offensively absurd in his sycophancy.

Yet there is something to his softness. The other men in the film, those involved in the film industry, are shown to be somewhat brutal if not short with women, whom they patronise and infantilise. Hrundi is different. Perhaps women and people of colour occupy a similar position in the psyche of the overmen, which is why his friendship with a coy French girl [Claudine Longet] who sings like Juliet Greco, is so touching. The woman and the Indian, both subject to the description of the other, the brown man coming from 'the dark continent' and the woman as 'the dark continent', can recognise one another as supposedly inferior. Both are assumed to be inherently childish.

As it happens, there's more to Hrundi's idiocy than pure idiocy. He seems like someone who could never be integrated anywhere. And his gentle foolishness and naivety become a powerful weapon. If you've been humiliated and excluded, you could become a Black Panther or, later, join Isis, taking revenge on everyone who has suppressed and humiliated you.

Or you could give up on the idea of retaliation altogether. You could perplex the paradigm with your indecipherability and live in the gaps. After all, who are you really? Not even you can know. When it comes to colonialism,

the man of colour is always pretending for the white man: pretending not to hate him and pretending not to want to kill him. In a way, Sellers's baffling brownface is perfect, for in some sense we are all pretending – if only that we are men or women.

Eventually Sellers's useful imp escapes the colonial power and leads a rebellion. Or, rather, an invasion in the home of the white master, involving an elephant, a small army of young neighbours and the whole of the frivolous sixties. The swimming pool fills with foamy bubbles into which people disappear, until no one knows who is who. In a carnivalistic chaos they all swim in the same water.

At the end of the movie, Hrundi and the French girl leave in his absurd little car. In both films, the Sellers character knows he has to be saved by a woman. And he is. Significantly, it is a white woman.

* * *

Walk out tonight into the London portrayed in *The Millionairess* and you will see the great energy of multiracialism and mixing; an open, experimental city, with most living here having some loyalty to the idea that something unique, free and tolerant has been created, despite Thatcherism. Out of the two films, *The Millionairess* looks the less dated, since its divides have returned. It has been said that Muslims were fools for adhering to an extreme

irrational creed, when the mad and revolutionary creed, all along, was that of Sophia Loren's family: extreme, neo-liberal capitalism and wealth accumulation, creating the Dickensian division in which we still live.

Equality does not exist here. This city's prosperity is more unevenly distributed than at any period in my lifetime, and the poor are dispersed and disenfranchised. Not only does our city burst with millionaires, many given to patronising urchins and the underprivileged, but a doctor committed to serving the financially excluded would be busy. London has reverted to a pre-1960s binary: a city of ghosts simultaneously alive and dead, of almost unnoticed refugees, asylum seekers, servants and those who need to be hidden, while many rightists have reverted to the idea that white cultural superiority is integral to European identity.

Since those two films with their brownfaced hero, we have a new racism, located around religion. And today the stranger will still be a stranger, one who disturbs and worries. Those who have come for work or freedom can find themselves blamed for all manner of absurd ills. As under colonialism, they are still expected to adapt to the ruling values – now called 'British' – and they, as expected, will always fail.

However, if the Peter Sellers character begins by mimicking whiteness, he does, by the end of both films, find an excellent way of forging a bond with his rulers,

and of outwitting them. If the West began to exoticise the East in a new way in the sixties, the Sellers character can benefit from this. For the one thing the women played by Sophia Loren and Claudine Longet lack and desire is a touch of the exotic and mysterious. It becomes Sellers's mission to provide this touch.

For Kabir and Hrundi, the entry into love is the door into the ruling white world of status and privilege. To exist in the West the man of colour must become, as the psychiatrist-philosopher Frantz Fanon would put it, worthy of a white woman's love. A woman of colour has little social value, but a white woman is a prize who can become the man's ticket to ride. By way of her, being loved like a white man, he can slip into the West, where, alongside her, he will be regarded differently. Perhaps he will disappear; but maybe he will alter things, or even subvert them, a little, and their children will either be reviled or, out of anger, change the world.

A Hollywood ending tells us love must be our final destination. Yet there is more complexity to these lovely finalities than either film can quite see or acknowledge. Birdy num-num indeed.

If Their Lips Weren't Sealed by Fear

Antigone is a particularly modern heroine. She is a rebel, a refusenik, a feminist, an anti-capitalist (principles are more important than money), a suicide perhaps, certainly a martyr and without doubt a difficult, insistent person, not unlike some of Ibsen's women. More decisive, less irritating, talky and circular than Hamlet – but, you might say, equally teenage – she has blazed through the centuries to remain one of the great characters of all literature. Is she a saint, a criminal of extraordinary integrity, a masochist or just stubborn and insolent? Or even 'mad', in the sense of impossible to understand?

Although psychoanalysis is not a determinism, with the parents Antigone had – the self-blinding Oedipus and the suicider Jocasta – you'd have to say she didn't have much of a chance. Nonetheless, she is a splendid, fabulous creature, with all the romance of the outsider, vibrant in her hardness, even as she is wildly frustrating in her intransigence.

She is also a wonderful part to play for an actress. We must never forget, after all, that *Antigone* is most famously a play of Sophocles, in which a young woman

defies a king and the law in order to follow her own conscience. It is the story of an individual against the state.

The text, described by Hegel as 'one of the most sublime, and in every respect, most consummate works of human effort ever brought forth', is a contribution to showbiz and not a thesis, although as a character Antigone is infinitely interpretable and has been repeatedly written about by philosophers, psychoanalysts, feminists, literary critics and revolutionaries.

The 'anti' in the name Antigone should be emphasised. What she wants, the strong desire from which Antigone never wavers, is to bury her beloved so-called traitor brother Polyneices – lying dead and neglected outside the palace walls – with ceremony and dignity. This is essential to her; she is absolutely clear: her brother will not be carrion for dogs and vultures. She will have the rituals of mourning, despite the fact his body has been dumped outside as a punishment for fighting against his native city. Sophocles is not talking about oppression as we would understand it. The society he describes is composed of the privileged, and of artisans and slaves. Antigone does not want to overturn this, but she insists on rebelling, on having things her way, on transgressing.

Since this is a father–daughter drama, Creon, her adversary and uncle, the man who could become her father-in-law, and who is a kind of daddy substitute, is a tough guy. Creon is a leader, a clever politician with a

Mafia don side, a primal father to whom all the women must belong. He is not the sort of man to be mocked or out-thought by a young woman, one who is determined from the start not to admire him, and who is set on undermining him. As he insists, 'The laws of the city speak through me.'

Creon, then, like her own father, for whom she cared for many years, is self-blinded. There is much he cannot afford to see or acknowledge. Antigone, on the other hand, with no children to protect, can enter 'the domain of men' and attempt to persuade Creon to understand her, to recognise the absurdity of the law. She is his perfect foil and necessary nuisance, ideally placed to see on his behalf, to tease out his weaknesses and torment him.

Though Antigone is betrothed to her cousin, Creon's son Haemon, Creon insists, not unreasonably, that the law, which replaces the agency of individuals, has to be obeyed. There cannot be exceptions. That is the point of the law: it is absolute. But for her the law is pathological and sadistic, and ethics are ideology. She is uninterested in happiness – she is accused by her sister Ismene of 'loving Polyneices being dead' – but the play is certainly concerned with enjoyment. If the law enjoys itself at our expense, she will also enjoy herself, perhaps too much, taking her sacrifice to its limit – death, and even beyond, into 'myth', ensuring that she will never disappear.

Antigone is certainly a feminist, a girl defying

patriarchy, a lone woman standing up to a cruel man. But she ain't no sister; there's no solidarity or community in her actions. She doesn't want to remove Creon and replace his dictatorship with a more democratic system. In fact, Sophocles is showing us here how the law and dissent create and generate one another, illustrating the necessary tension between the state and the people, the family and the individual, man and woman.

Antigone is, in some terrible way, bound to Creon in love, as we are inevitably bound to our enemies. She is no more free than he. This couple are fascinated by one another. What is terrible about Antigone is not so much her belief, but the way she assumes it. She is entirely certain. She is no paragon; and rather than being an example of someone who sticks to their desire, she is a person who cannot think, lacking intellectual flexibility.

Her intransigence mimics that of Creon. Indeed, the two of them have similar characters, neither having any self-doubt, scepticism or ability to compromise. Both are afflicted by excessive certainty, so that the two of them will always be on a collision course. Both are shown to be monsters, and both will have to die.

Sophocles' play, then, is perfectly balanced in the way it engages the audience, as it moves from argument to argument. It is a play of voices and an exercise in democracy itself, proposing no solution, but clearly displaying the most fundamental questions. There is no agreed-upon

good. The good is that which can be argued about, but there is no possibility of a final position without imposing it, a form of utopia which can only lead to fascism.

Every act renders us guilty in some way. It is as if we'd like to believe we can live without hurting others. But this beautiful story of 'demonic excess' can only end badly on both sides, with Antigone killing herself and Creon having lost his son, consumed with guilt and eventually murdered by the mob, his palace burned down.

Antigone could be described as a dialectical teaching play, a 'what-if', showing human action from numerous points of view, just as the point of psychoanalysis is not to eliminate conflicts but to expose them. The play doesn't tell us what to think, for it is not a guide to thought. It is another thing altogether: a guide to the necessity of perplexity. It illustrates a necessary conflict, showing that useful rather than deadly conflicts make democracy possible.

Love Is Always an Innovation

She was in the hotel waiting for him, a cheap place with a bad view. They were going to separate, that was the idea, after one last time together. It would be wild; the wildest.

She was in the hotel waiting for him and she had got there early to clear her head. She needed to keep her phone on for him, but the kids and Peter kept texting. She was with a friend who was ill, on his deathbed. She giggled as she lied, but they never let her alone, the only people she had. Her family were like family, she liked to say. And he, Mr Goodbye, was on his way.

She was in the hotel waiting for him. After practising, she had come to appreciate aggression in the bedroom. Nor had she been an exhibitionist before. She'd never been far beyond the decent. What a difference that made to her life, with everything else having to be reorganised to recognise her, the new person.

Until this, she had been with five or six men and had kept her eyes closed. Nervous, anxious enough to float the world on her worry, she had run from what she needed. She believed that this was how most people were. She was ashamed. She had been unwilling to accept

the wound. She had been too good for her own good. Sometimes you have to let people hate you.

Mr Goodbye was the only one who liked to talk. He asked for her wishes; he explained what he wanted to do. 'Open your mouth for my fingers, bend over, open yourself. Show me. I must see.' He made her use words too. She used them back now. You see, they were the thing.

A fat, hairy and busy man, a pig, a salesman, a liar and show-off, his voice more phallic than his cock. Every time with Mr Goodbye was an assault on everything she knew. He made her so avant-garde she wanted to bite his face off, carry it away and make everyone she knew wear it.

She was in the hotel waiting for him, staring out, her hands flat against the window, and there were jets crossing the sky. People were moving about more than you'd think. She took off her clothes, threw them down and paced in her shoes, a nude in a cube, feeling freer like this.

We are perverts in our imagination, and she was what they call beside herself. This is when you know you can't master yourself. Eros shoved her beyond, and sex is not justice, she'd decided. Desire and disgust were ever-loving twins: she wanted to be violent and loathsome. She wrote lists of wishes to remind herself which sort of loathsome she had in mind. She still couldn't understand where in herself all this alteration originated, or who you could ask about it.

She was in the hotel room waiting for him. At twenty

years old someone said she wouldn't understand pas-
sion until she was forty, or be able to bear it until
she was forty-five. Even then it wouldn't be too late.
Nevertheless: what a warning. But it was true, she had
had no idea what a body could do. You had to thank
anyone who made you so irrational.

She was waiting for him and knew that even now her
lust was too tempered by something like love. When she
saw his face she was more tender than she'd intended,
kissing him too much. He had stripped her to her bones.
People say you should learn to live without leaning on
others. But what if they are so good for you that you for-
get everything else?

She was in the hotel room waiting for him, and thought
she might roll under the bed so when he came in he'd get
a shock. He would stand there with his baffled look on
and begin to understand what it would be like to be with-
out her, that beyond here there was no bliss. He might sit
down. He could ruminate.

She was in the hotel room waiting for him. She didn't
want to scare him. She wanted to smoke but the windows
wouldn't open. She wondered if he liked her because
she'd had breakdowns and been locked up for having a
runaway mind. Maybe he thought people like her would
do just anything.

She was in the hotel room waiting for him, and soon
that, as they say, would be that. They had done everything

people could do together; she still wanted him, she could do it again, but she had a family. He wanted a girlfriend to share a croissant with, not a berserker to look around a room for.

She was in the hotel room waiting to see the grey soles of his feet. Soon she would be giving up the thing she enjoyed most to rejoin the tribe of the Unfucked. He made her laugh but she was beginning to bore him. The mad were those who put others off. She feared loving him more than she feared death. Passion made ordinary life impossible and interfered with the ground zero of reality, thank God.

She was in the hotel room waiting for him. She enjoyed her children; her duty was to take care of her ill husband. With him it was like trying to make love to your mother. Morality was where you gave up what you loved in order to satisfy someone you disliked. Now she'd discovered that this ugly man was the best thing of all. But how did these ideas touch one another?

She was waiting for him and there was much she didn't want to know. After this she would fanatically try to forget the things that mattered most to her.

She was in the hotel room waiting for him in the hours and minutes and seconds before he became a ghost and she would return to her senses. She was in the hotel room waiting for him, and anyone anywhere waiting for anything is waiting for love.

Excessive, Explosive Enjoyment

When we were teenagers in the late sixties drugs were new. Not only for us, but for our parents and for the culture. We stranded suburban kids out in Kent knew that something strange had been going on in London because even the world's most popular group, the Beatles – who had been respectable and decent but had now got weird with their colourful clothes and unusual hair – had talked about it. The music they made in their great middle period was concerned with tripping and smoking and swallowing stuff that appeared to take your mind into a free, uncontrolled zone where the usual rules didn't apply, where you might see that which was ordinarily hidden.

This music was about freedom and leaving home, and, particularly at that age, freedom meant a lot to us. The boredom and violence of school, and the drudgery which had been planted ahead of us – work, mortgage, debt, child care – was already heavy. Our future and what was expected of us had been laid down early. It wasn't thrilling and we weren't ready for it.

The London suburbs were not as affluent as the American ones. Our area, Bromley, was still wrecked

from the war. The food was repulsive, the men wore bowler hats and education was an endless sadism. But *The Graduate* spoke to us pretty things. As Benjamin Braddock realises in Charles Webb's funny novel and Mike Nichols's film, when he returns home from university his parents' world looks false. From the kids' point of view, the way the adults lived seemed crazy. Who would want to fit in with that uncomfortable, John Cheever world where everyone should be content and yet was not? Their unhappiness and discomfort was plain, and their pleasures – of alcohol and promiscuity – were half-hidden and guilty. Their pleasures weren't even a pleasure.

In those days people still talked about alienation, and David Bowie knew what that meant with his talk of spacemen. We were the wrong people in the wrong place. Some people said that art could change the way you saw things. But somnolent Mozart, or Hollywood movies, or Renoir paintings couldn't make the revolution we craved.

Then we heard Little Richard and Chuck Berry. Occasionally we could see the Rolling Stones or the Who on TV. Suddenly we became aware of a dirty, obscene noise which violated all decency and which represented a heightened pleasure we hadn't encountered before. It led to the fatal association: pleasure was insane. Too much of it could make you mad. Like sex, it was excessive. You couldn't grasp or understand it, but you wanted it, and it could make you dance and want to be creative.

Music – not the cinema, television or the novel – was the most significant cultural form of the day, and it changed everything for everyone.

It was sometimes said the country was awash with drugs, but try scoring when you needed something. In the late sixties mostly we smoked hash, took amphetamines and downers, and dropped LSD, often at school. Baudelaire, writing on drugs, reports an encounter with what he calls 'the marvellous', but notices an increase in anxiety and paranoia when taking hashish. He also tells us that one is no longer master of oneself. You lost control. This might be an inspiration in itself. You could see and feel things stoned that you couldn't know straight. There might be enhanced communication. If you were less cautious and uptight, you might be able to speak and laugh more. If you lost your straight self, you might discover a better one. You might want to live differently. That became the promise. After all, people had been using substances to twist their minds around since the first day on earth: coffee, wine, tobacco, mescaline, mushrooms, a plant, or something else. Early religions used drugs to gain some kind of sublime knowledge, as a way of enlarging the frame through which to see out.

We were less harried, harassed, measured and legally drugged than children are today, and the adults were more neglectful. The fact that drugs were illegal and disapproved of made them doubly exciting. Breaking the

parents' law, or indeed any law, was a big kick in itself: you could believe that by arguing with prohibition you were making the world a little wider.

Post-war capitalism had started to work a treat for some people, and in the suburbs workers had started to become consumers. Capitalism gave us nice things we didn't have before, and which most people in the world still didn't have: new kitchens, better jeans, LPs, fashionable shops. Our neighbours boasted about their sofas, fridges and TVs. It was tough to keep up. But there was no doubt the bombed-out neighbourhood and miserable pre-war housing needed cheering up. My mother had washed our clothes by hand; getting a washing machine made a big difference.

Writers like Baudelaire, de Nerval, Huxley and, later, Tom Wolfe and Hunter Thompson wrote about drug-taking among the artistic elite. Now, for the first time, drugs were generally available and, like pop, they had reached the suburbs. And the drugs we began to take in one another's bedrooms, in the parks and later in the pubs represented instant pleasure, while everything in the suburbs was deferred. Consumerism was about patience, waiting, slow accumulation and gradual improvement. Capitalism no longer starved the workers, but it starved them of pleasure. We were supposed to work, not make love. We were made aware that happiness, if not pleasure, was always elsewhere.

The West had been growing out of God. Religion was going but hadn't quite gone, and was yet to be entirely replaced by consumerism. The threat of God's disapproval was still used as a form of control. Yet as we drifted around in our tie-dyed granddad vests and ripped jeans, hiding from mods and skinheads, we knew that the game of traditional authority was up and that the laws we were brought up to respect weren't sensible. Drugs were prohibited but worse things were allowed, if not encouraged: genocide, war, racism, inequality, violence. No one would kill their own children, but they were keen to kill other people's. We didn't believe the grown-ups, who were not grown-ups after all. The levelling of generations had begun.

Also, as the 1970s progressed, capitalism – which required everyone to be anxious and hyper-alert – began to falter. The system was more anarchic, bumpy and unpredictable than politicians made out. It went up and down quickly, and you went with it. The very things that capitalism liked to promise – growth, wealth, increased consumption – couldn't be delivered. Soon there would be unemployment, social devastation and 'No future', as punk recognised. And yet capitalism could never be abandoned. Since the end of socialism, it saw itself as the natural world. The only way forward was to find a place inside it which wasn't impossible, hence the retreat into spiritualism, yoga, Zen and mindfulness. Or more drugs.

But what could you do stoned that you couldn't do straight? We were less anxious and concerned about the future. We laughed more and could entertain ludicrous and creative ideas. There were other claims, many of them risible. There would be a thousand epiphanies at once. William Burroughs, at the end of *Junky*, writes, 'Kick is seeing things from a special angle. Kick is momentary freedom from the claims of the ageing, cautious, nagging, frightening flesh. Maybe I will find in yage what I was looking for in junk and weed and coke. Yage may be the final fix.'

But 'drugs', when they first became generally available in the sixties, caused such outrage and consternation that we understood it wasn't the undoubted damage they did which was the problem. The drawback wasn't the possibility of ill-health or addiction but the instant pleasure which drugs provided. Or at least the pleasure others believed they provided. This was what R. D. Laing called 'a mental Shangri-La' – the longing for something 'beyond'.

In the 1990s and 2000s, drugs went respectable and mainstream. Ritalin, Prozac and other anti-depressants – substances which fixed adults and children up for work without the agony of self-investigation – became the royal road to efficiency. A subject's life and the significance of symptoms were replaced by biology and the language of science; chemistry replaced an individual's history and doctors were substituted for self-authority. We had become

machines which dysfunctioned, not individuals with parents and a past that might be worth exploring in talk and art, wondering why, inexplicably, we were fatigued or exhausted. There were no illuminating questions or slowing down. The important thing was to function, to work, compete and succeed. Drugs, cures and ideas about what a self was had become an arm of capitalism.

Pleasure, the devil's elixir, a magic substance more valuable than gold, is always a source of anxiety, which is why pleasure is usually located in other people or groups, where it can be thought about, enjoyed and condemned. The danger of drugs was not the fact they made for disorientation, if not madness and addiction, but that they provided too much unearned illicit, or even evil, enjoyment. Drugs were an idiot's euphoria. The story was: if you liked it, or couldn't make money from it, it couldn't possibly be good for you.

Of course, after so long, we now know that neither legal nor illegal drugs are *it* either. For a time they seemed to promise freedom from the cycle of work and consumption. But rather than representing a point outside – a place of rest, spiritual enlightenment or insight – they became the very thing we thought they might replace. Soon we would see they created as much dissatisfaction as any other cheap fetishised object.

All ideologies are concerned with constraining pleasure. But the capitalist system didn't just do that. It was

smart enough to encourage pleasure and even happiness, seeing how lucrative they could be. It was miraculous the way capitalism swept everything inside itself. Those who were stoned but original made capitalism dynamic because the system stood on those who defied it. The druggiest music made the most money for the record companies and, soon, even depression became monetised. It became the rule: everything which once outraged would soon be domesticated, if not ordinary, and not only in music, the visual arts and literature.

The druggies, from Baudelaire to Kerouac, had learned that the route to paradise wasn't simple. Though Baudelaire talks of stoned bliss, of calm, of a place where all philosophical questions can be answered, and of a liberating vulgarity, he makes it clear what hard work it is having a good time all the time.

Figures like Baudelaire and Kerouac were artists first, and stoners after. The demand for pleasure can become infernal, and another form of authority. And while drugs might make you poetic – filling the gaps in reality – they can render you useless, if not impotent.

No one believes in drugs any more. At least in art there is movement and thought. Working at something intransigent, one can make and re-make oneself, combining intelligence with intuition. Drugs, when they are effective, abolish ambivalence. But being an artist can never be straightforward. You must cede control and give way

to chaos. In art, as in any other form of love, there will be strong feelings of attraction and of abhorrence. Artists may love what they do but they also hate it. Work can become a tyranny and treadmill. It is boring; the material resists; the audience might be uninterested. It can never be an uncomplicated or straightforward pleasure.

Not only can few artists make a realistic assessment of their own work, their state of mind cannot be expected to be serene. There can be no art without anxiety, self-disgust, fear of failure and of success. It is hard and dull labour, and can feel forced. Notice how it is almost impossible to convince an artist how good their work is. But that is the price of the ticket. At least one is going somewhere.

London: Open City

In 1957, film and theatre director Lindsay Anderson wrote a short polemic for the essay collection *Declaration* on the 'ordeal' of 'coming back to Britain'. He bemoaned 'brown sauce bottles', 'chips with everything' and the 'nursery' atmosphere. He implied that on the 'Continent', as it was known then, everything was better. The food, the weather, the philosophers, and certainly the sex.

I was younger than Anderson and suburban rather than provincial, but his analysis hit home. Throughout the sixties, we wanted Britain to be less foggy, class-bound and monocultural, with the pubs open in the afternoon. After the collapse of Empire and loss of imperial power, we imagined a less isolated England, a Europeanised, cosmopolitan country, with more of the world in it. That world would bring the excitement of the new.

And it did. It happened. London, driven by culture and finance, became an energetic, successful, multi-cultural, multiracial super-city, superseding the best of Paris, Berlin and Milan.

By chance I have lived in west London all my adult life, and was keen to bring up my three sons in this mean,

ever-changing city of immigrants and strangers, where the boys could go out and not know who they'd meet or what they'd see. I hoped they'd never feel as stifled as I did in suburbia, with its 'Sunday death' every day. And although the city and the action have moved away to east London, I still haven't recovered from the excitement of being here.

Throughout the 1980s, when I was writing hard, intent on making a career and living from my pen, there were parts of London that I loved to walk around in the afternoon and evening. Soho, Chelsea, Notting Hill: places to hang out and observe the scene, and see who you ran into, because there was always the possibility of some dark excitement, when the night would develop.

Once, these districts had *the* recipe: a blend of seediness if not squalor, romance and sex; art, violence and, most importantly, social mixing. These districts got better and better, until they became worse. That was when the rich took over, and we learned that there's nothing like money to erase the charm from anything good.

A city which has lost its loucheness has lost almost everything, and we were proud to say, 'They'll never gentrify the Bush.' For a long time they didn't. Shepherd's Bush's disarray and ugliness were surely ingrained and ineradicable. But even this area, made famous by *Steptoe and Son* and the Who's *Quadrophenia* – and where Dickens opened a house for 'fallen' women – is starting,

in the part that drifts towards Hammersmith, to resemble a minor futuristic Manhattan, with gyms, blank towers, and blank, discouraged workers.

And yet: one unforgettable night not long ago, further north, on the Green, we paid £12 to go into the Shepherd's Bush Empire to watch Prince play for three hours, one hour of which was in the dark, as he sang alone at the piano. Recently we saw Bloc Party tearing apart the Bush Hall. And luckily, around the corner, parts of the Goldhawk Road, and a good deal of the Uxbridge Road – a wide street, one of the longest in London – have stuck to the magic recipe.

A babel, if not menagerie, of Polish, Somali, Syrian, Afghani, Arab cultures – and a sufficient mix of dereliction and danger: my youngest son says you don't even notice the fights – it is a uniquely mixed part of London, where people use the street as their office. A Thai restaurant, Lebanese bakery, hijab shop, Polish deli, mosque and the beautiful Bush Hall Dining Rooms sit side by side. Sometimes I wonder if I'm the only English speaker in this city. You could be in the Third World. This is nowhere and everywhere, and an exceptional experiment.

Bustle, noise and new people every day: this district is what a city should be. A frenzy of communities and of individuals, if not eccentrics; a place that thrives on change, and where you can be who you want to be. Freedom counts for a lot in these turbulent days. Mind you don't lose your faith in other people.

Where Is Everybody?

One early evening in Rome, a few months ago, my Italian girlfriend and I decided to go out for supper. We would drive to Trastevere, stroll around until we were tired, and then find somewhere to eat. We did this on a delightful evening. For me there was nothing wrong in the world when we sat down at last on the terrace of a promising place and ordered wine. The streets were crowded, the views were beautiful, you could see a gargoyle or madonna on every wall, and despite my complaints about the monotony of Italian menus, I was keen to eat.

While we waited I thought: don't look at your phone, look at the world. Look at the people, and mark what you see. And this is what I did, until I became aware of an odd feeling. I found myself asking a question, which became persistent. Where was everyone? I mean, really: *where were they?*

Everywhere I looked I saw only white faces: tourists, passers-by, waiters, diners. At one point a poor Bengali approached me with a rose, and I wanted to ask him what he was doing and how he managed to make out in all

this beauty and whiteness. But he was busy begging and smiling, and soon disappeared. When I looked out again at the street I saw that what I had noticed was not inaccurate. Everyone was the same colour: white.

For a moment I entertained an odd thought about this uncanny event or emptiness. What if the city had been subject to a bizarre sci-fi occurrence, as in a movie, and all the people of colour had been teleported to another time or galaxy? Maybe they would be back soon, mingling with the whites, and the world would return to normal – a mixture of races and peoples, mingling together.

But perhaps they wouldn't be returned. In fact, I knew it was the case that they wouldn't be back, because they were never there in the first place. And I knew I should have long become used to this odd thing where you feel like the stand-out person. I grew up, after all, in a white Kent suburb and went to a white school. The books I read were by white people; all the politicians were white, and so was everyone who appeared on television. Later, at university and working in the theatre, it was the same.

As the lovely evening passed, an exception came to mind. I remembered reading, as a teenager, a beautiful essay by James Baldwin, 'Equal in Paris', published in 1955 in *Notes of a Native Son*. At the time, the piece scared me like a nightmare, because in it he describes being arrested and flung in jail for eight days after being given a bed-sheet by a friend, who had stolen it from a seedy

Left Bank hotel. Baldwin knew that in Paris a man of colour would always be regarded with suspicion, and he writes of how 'ancient glories' can create paranoia in the original population, whose culture has stultified, making them vain and inward-looking, thinking only of how to maintain their position.

Since then, leaving London for Paris, Milan, Stavanger or wherever it might be has always made me nervous, not only because one is anonymous, but because people have ideas about people of colour that they don't have about whites, and those ideas can get you into trouble, as any Muslim who has passed through an airport can tell you. Whites don't understand how nervous we can get; they can't see the reason for the paranoia, which they consider to be an exaggeration. But the first thing you notice about someone is whether they are a man or a woman, and what colour they are, and about that you will have a mythology which is rarely in the favour of the person of colour. So the question for us is: *who are we* in an increasingly dangerous Europe today? And what will become of us?

I love Rome better than any other city because it is the most melancholic of all the great European cities, sad and almost tragic in its dereliction and neglect. I think of hunched old women in black, and elderly intellectuals in jackets and ties, out of time and place, talking only to themselves, like characters from a Chekhov play.

Graffiti'd, falling apart and seemingly uncared for, the city reminds me of anarchic and free London in the 1970s, or a place where there has been a great party where the beautiful people have gone home and no one has the heart to clear up. I love the romanticism of Rome but I pity the young in their hopelessness. I would never want my children to try and survive there, even as I wonder why the part of west London, where I live is increasingly becoming Italian, and there are more and more Italian voices on the street. What are people leaving for that they can't get at home?

Dereliction may be beautiful for a visitor, but not everything old is cute. And the despair which accompanies decay makes people cruel and blame others for their misfortunes. It is not only the foreigner who is not integrated, but the local person who increasingly feels he has no place or future.

The recent great Italian television shows, *Gomorrah* and *Suburra*, of which I am a great fan, are campy, fantastical tales for a foreign market. But we know that fiction has the face of truth. And the stultifying, incestuous, xenophobic atmosphere of these shows – with their characters who destroy their own communities, and eventually themselves, because there is no light or air, and the people are sick of one another – could be a lesson in what we need to develop.

Looking out at the city and wondering what it will

become – and wondering how fearful one might become, according to the role one is being assigned – one cannot help but think: civilisation cannot be left in the past. It has to be something which is maintained and re-made every day in every act of exchange, in every act of welcome and recognition.

Two Keiths and the Wrong Piano

Just before Xmas in 2017, having had a minor operation, I was lying in bed, bored, uncomfortable and in no mood to read, when for reasons I can't explain I thought I'd listen to Keith Jarrett's *Köln Concert* all the way through. I'd played it massively over the years, on record, cassette, CD, and now on download. But since I tend to listen to music while doing something else – reading, writing or looking out of the window – I can't say I'd actually *heard* or immersed myself in it for a long time.

I recalled that the double album was recorded live in Cologne in 1975 and a lot of people bought it, even those who would never have listened to anything quick or abstract by Charlie Parker or John Coltrane. Musicians – not novelists, movie or theatre directors or painters – had been at the centre of the culture I grew up in. They were our political and spiritual guides and we considered it crucial to keep in touch with what they were thinking. Despite this, for some unknown reason I didn't hear the album until around 1987.

I remember being depressed at the time because I told everyone so, and then I left London briefly, to stay with

Karen, in Cardiff, Wales. In the early seventies, we had been at college in Bromley together, doing our A-levels, and she was the first female friend I'd had. It was not a romantic attachment: better educated and more cultured than me, she was right of centre then, argumentative and good fun to be around. She often came to the house, and my father liked to talk with her. He encouraged us to start a magazine together, which had one issue.

In Cardiff, expecting her to welcome a definitive account of my depression, I arrived to discover that she had married a Buddhist and become one herself. They were wearing orange robes, burning incense and sitting still for long periods. I was appalled: how happy they were despite being ridiculous, having no drugs in the house and wearing a colour that did no one any favours. I grasped that not only would I receive little attention, but that afternoon they also wanted to see *Raiders of the Lost Ark*, which had just been released. Of course, its optimism hurled me into a blacker mood. A good Tarkovsky might have elevated my spirits.

My mood would turn darker that evening. Buddhists, according to my bias, tended to listen to chanting music or something somnolent suitable for aromatherapy. The new Thatcherite capitalism was depleting and exhausting people. If you couldn't keep up, you could cross your legs and check out. Nietzsche called Buddhism 'a kind of hygiene'. But I was half asleep already; I wanted to wake

up and tune in to the cosmic meaning. That was why I was there.

Karen's husband, who I had taken against – particularly after seeing the devoted way he held and caressed her foot when we visited a shoe shop – put on *The Köln Concert,* which I knew nothing about. When he informed me that the piece was an improvisation, I suspected my visit would be short. In the 1970s and early 80s, I had worked in the theatre, and at that time directors liked to use improvisation to 'free the actors up'. These exercises were interminable; I had never seen an actor achieve anything through improvisation which wouldn't have been better coming from a writer who had thought about what he was doing. But, having no choice – 'the ears have no lids,' as Jacques Lacan reminds us – I listened. And those first five notes knocked me out; it was like receiving five firm blows to the head.

That night we had supper, and a young woman friend of theirs came round. When the woman had gone and the Buddhists were in bed, I retired to the attic, where I was staying, and waited. In those days I was an enthusiast of one-night stands, where a never-repeated intensity and strangeness might occur with an unknown person who would remain mostly unknown – apart from their obscenity. Hoping for what Robert Stoller calls 'reciprocated pathologies', the couple would become and remain a kind of living fantasy for one another. That was the idea.

51

Earlier, the girl and I had whispered together. Now, she came back. We lit candles; I crept downstairs for the record. We lay on the bed together and played it all night.

I curled up. Everything was wrong with me. Suffering from lack of curiosity, I was too fearful and inhibited to have sex with her, if that was what she wanted. Or, indeed, if it was what I wanted. Sex rarely lacks trauma; it is almost always shattering and there are few insignificant sexual encounters, however fleeting.

But I lacked the sense or ability to inform her of how I felt. If speaking is obviously the most important thing we do, I could have tried that. She might, after all, have wanted to hear and respond.

Certainly I had always considered it more profitable and interesting to talk with men than with women. My father and I had been close, and I had witnessed how much he and his brothers liked to talk. In contrast, my mother avoided social situations and conversation. She was already nervous, if not frightened and trapped. Later, I understood that the freedom to speak, joke or tease could never be enjoyable for her. Petrified, secluded and busy trying not to go mad, more talk would only disorientate her. She was enigmatic to us, and appeared to have little idea of what was going on inside herself. Not that she wanted to be helped. She didn't think it was necessary that people be interesting, funny or attractive. On the rare occasions that people came by to see us I wanted

them to have a nice time and like us. Once, when I was enumerating the qualities of someone I liked, she interrupted to say, 'Why can't people just be nice?' My analyst said that that was a profound remark. Clearly, he was on to something. He's nice himself, but I can't imagine that people pay him for only that.

That night, what I called depression was rigidity and repetition; a taste of bitter nothingness. I was lost and afraid in a dark wood, with no capacity to enjoy my own thoughts or those of anyone else. I could enter a tunnel of all-debasing, tantrum-y fury, where things would get dirty in my head and I'd be tempted to throw myself under a train. Who doesn't know someone who has killed themselves, and even admired their courage?

Stephen Frears and I had made *My Beautiful Laundrette* and *Sammy and Rosie Get Laid*. I had some money for the first time and not long before had been at the Oscars, sitting next to Bette Davis, who had been kind. Now I was at some kind of crossroads. I knew I should begin the novel I had been attempting since my teens, which would become *The Buddha of Suburbia*. But I didn't know how to start. I couldn't find the right voice for it. Or a voice for myself.

* * *

Having successfully sabotaged the Buddhist couple's weekend and more or less lost Karen as a friend, back in

London I bought *The Köln Concert* on cassette because I needed to know it better. The sound is thin and you can hear Jarrett sighing, foot-stomping and making Glenn Gould-like grunts. He was twenty-nine, and exhausted that night. The concert took place late, after another concert had finished, and Jarrett almost refused to play because the young promoter had provided the wrong piano. It was only after some persuasion, apparently, that he played at all, or that the gig was recorded.

The Köln Concert is a textured piece: you can hear in it pop, gospel, blues and a little bit of schmaltz, but Jarrett never stays anywhere long enough to settle. He is all over the place. Not only did I understand that the music was original and somehow visionary, but that it was intensely rich – carrying in it the compressed history of everything Jarrett ever knew – so that even today I can detect hidden corners in it. And who couldn't acknowledge that it took a wild confidence to sit in front of a thousand people and invent music that didn't exist five minutes before? Rapturous, possessed by music, he had – and yet hadn't – exposed himself to an exhilarating danger. How could anyone be that free? Nietzsche, himself a keen improviser on the piano, has something to say about this in *The Gay Science*: 'One is reminded of those masters of musical improvisation whose hands the listener would also like to credit with divine infallibility although here and there they make a mistake as

every mortal does. But they are practised and inventive and ready at any moment to incorporate into their thematic order the most accidental tone to which the flick of a finger or a mood has driven them, breathing a beautiful meaning and soul into an accident.'

It also struck me, as I drank in the record – whose beauty slowly began to convince me I needn't kill myself that afternoon – that satisfaction and happiness wouldn't happen for me today, or for a long time. My response to the music had reminded me that, concealed inside myself, was a more excitable and open self raring to get out. But I knew it could take years to chase away one's defences and live more freely. You couldn't take a pill for it. You had to *do* something. I had read in the Freudian literature that you had to 'work it through'. How did you begin to do that?

My Beautiful Laundrette had been about two aspirational, gay oddballs – a skinhead and a mixed-race kid – who become entrepreneurs almost by mistake. It matched its time: extreme neo-liberal capitalism was gathering speed; society was being sorted into winners and losers. Where there had once been generational solidarity and a sense of shared, counter-cultural values – for the liberalisation of the West – there was now, in this new era, the cry of 'no future' and the banal mantra of celebrity and accumulation. Not only that, this was the era of self-help. You were supposed to retool

yourself for the new era. In the light of this, even I grasped what was stimulating the Buddhists. If all was acquisitiveness, competition and entrepreneurship, sitting on your arse could seem like rebellion.

I was too restless and ambitious for extended meditation, and I regret that I probably still am. But I began to think about something related to meditation. Suppose you put aside, or entirely gave up, ideas of success and failure, and only proceeded experimentally, following your interest and excitement? What if you retired what Rousseau calls 'the frenzy to achieve distinction'? Didn't that resemble what Jarrett was doing when he turned up not knowing what would turn up? Wasn't that a lateral, Buddhist act?

When I was at school we were neglected when we were not being punished. But now there were fresh horrors for children, and new forms of discipline. Every day had become a test. Goals were set. The young were harried and pursued in search of some spurious ideal of excellence and achievement. Putting all this together, and recalling that refusal makes us human, I had been thinking of writing a story about someone who one day rejected the idea of duty and obligation, and decided to live only according to his pleasure, following what you might call 'alternative selves', seeking an 'alternative life', re-evaluating his values. He would, of course, soon exhaust the obvious indulgences. If he didn't insist on

making himself crazy like Dorian Gray, how might he proceed? Where would it take him, this commitment to surprise, and what would happen as a consequence?

I never found a way to order this story. But I wanted to try and write a book about my own discordance. Despite my state of mind, most of the time my discipline hadn't deserted me. It would always come and go, but most days I would drift across to my desk, read a bit of what I had written previously and cross it out. Usually something kicked off then. Beginning a new piece created some hope and optimism. I embarked on the novel because I had to, starting it simply with the most elementary state-ment, having the protagonist announce himself, as we did in workshops. 'My name is Karim Amir and I am an Englishman born and bred, almost . . .'

A few days ago, after listening to *The Köln Concert*, I was prompted to glance again at Keith Johnstone's teach-ing book *Impro*, which we'd used at the Royal Court, where Johnstone had worked. Despite my scepticism with regard to exposing others to your improvisations, unless you were Keith Jarrett, this paean to fluency and spontaneity made me so enthusiastic I read it again. I have to admit I adore books which contain instructions.

Freud was always a moralist. Trying too hard to be obe-dient or good, we become masochistic because morality in its purest, Kantian form is pathological and asks too much of us. Winnicott, in *Playing and Reality* (1971), discusses

the idea of the child being asked to give up their spontaneity in favour of compliance, and what the price of such obedience is. Published in 1979, Johnstone's *Impro*, with its hippy edge, is an immaculate guide to not doing the right thing, to being careless, indecent – and altogether crazier. Wisely, Johnstone calls education 'an anti-trance activity', and suggests that by forgetting your manners and being less impressed by the rules, you can allow surprising things to happen. True speech might even emerge, if we remember that speech isn't something you can rehearse; it really is always an improvisation, and the more digressive the better.

However, unlearning is a risky art. If art is controlled madness, then lack of control, and following pleasure, could take you anywhere. Could you be sure you wanted to go there, particularly with other people? Pleasure is an energy, and once you understand that it is a creative force – that is, *the* creative force – you might begin to get somewhere. I saw that pop had always used this as a creed.

It would be a while before I saw that a series of indifferent relationships weren't experimental. They weren't even relationships. I was narrowing my mind, if not mortifying myself. And after studying Jarrett, I saw that some artists – particularly musicians, like Prince, whom I would think about when I began my second novel, *The Black Album* – never stopped producing.

But the idea of becoming more productive wasn't *it* either, because I was beginning to see that although being an artist seemed to represent the ideal life – you follow your imagination and get paid, if not praised – it could never be sufficient. Talent can become an obstacle, and making art can become a way of retreating to a bunker where you would feel safe. I wondered if Jarrett had made that mistake with his work, and if he had learned from it.

Most of the time you have to be a person with another person, and if you're lucky you can play with them, making demands and expecting demands back. New things emerge from this exchange. But facing other people straight on in their reality, with their odd, if not strange, pleasures – and what, if anything, do they want? – could be too much. Racism, misogyny and other forms of inequality are intended to modify this impact by diminishing the other from the outset. They come to you already filtered so you know what they are. Status is a form of protection, and equality the horror to be avoided. If speaking is a performance, then this form of improvisation is an attempt to find out what is unknown about oneself and others. And the unknown is, as the two Keiths knew, where the excitement lies.

It Feels Like a Crime:
The Devil Inside

A writer sits at her desk and wants to put her hands over her ears, like a child being shouted at. Her head is filled with aggressive, disapproving thoughts about why she is there, the point and profit of it, and whether she is the sort of person who is allowed to do this. The shouts, she knows, come from her and, strangely, not from her. Whatever: she cannot concentrate or enjoy her work. She interrupts herself until she is abject, having failed before she has begun. Suppose this unpleasant ritual is repeated every time she attempts to begin, as something she must endure as the price of getting started? Familiar at all?

Of all the questions authors get asked, the most puzzling but persistent concerns what others might think of what the writer has produced. These others – these potential disapprovers – might be the writer's spouse, her family, her colleagues, community or neighbours. It doesn't matter exactly who they are. Yet the question of these opinions is clearly a crucial one for apprentice artists. When they begin to work, a chattering chorus of censure and dissent, if not of hate, starts up inside them. The writer becomes

inhibited by concerns about the effect her words might have. The writer could become anxious, stifled or blocked. She could feel phobic about beginning, and begin to hate her own work and, indeed, herself.

In truth, when someone begins writing, they will have no idea what they will say, or what anyone will think. It's an exploration. If the writer has some level of integrity, she will always do her best work and will eventually discover, once the work is done, whether others are indifferent, wildly enthusiastic or something else altogether. But the assumption of the anxious writer engaged in this prior doomscript is that she has already aggressively provoked or hurt someone. Not only that: these 'neighbours' will retaliate. There will be guilt and a terrible conflict, so why bother at all? Why get into this?

This elaborate rigmarole has a notable idea in it. Words are dangerous – they can upset, thrill, provoke and change lives. This is useful knowledge. Good writers must always remain aware that they are performers, working not only for themselves, but to ensnare the reader with magic.

But how to start? What of these chattering 'neighbours'? Why are they present? What are they doing in this internal nightmare?

From one point of view, worrying about others could be called conscience. Nevertheless, a more effective description of what is taking place is the notion of the superego, an idea Freud developed after the First World War, linking

it to hate, depression, masochism and what he called the death instinct. Conscience implies concern, if not decency. It lacks the devilish, if not sadistic, dimension which the idea of the superego has, where the so-called good becomes an obstacle to exploration. So it is not that the writer has committed a crime of speaking out, but rather that she is already guilty of something or other, and always will be.

Ultimately this question of whether one can speak is not a moral one, concerned with doing harm to others. It is about self-harm, the enigma of self-persecution, and how you can begin to fear your own words and imagination. The writer might be a voyeur who likes to exhibit herself. This is partly what it means to present something to an audience: the wish to be known, to inhabit a persona, to tell stories, a desire which will be accompanied by a certain necessary shamelessness.

Nevertheless, even as we speak we also wonder, according to the tough logic of the superego, if we are more monstrous than we can bear. We believe that if we were good, we wouldn't have aggressive or violent thoughts, forgetting that monstrousness is useful in art, which, to be effective, has to be pushed to an extreme, making the audience tremble. Art emerges from what Nietzsche called 'inner anarchy', and never from so-called decency. This anarchy is a formidable tool, a method of generating thoughts you never knew you had. You are more original than you ever knew.

Of course, a critical faculty, of judgement if not ruth-lessness, is essential. Any artist must be able to look over their work with a clear, impartial eye, reading it through and dismissing this or that, and retaining the good enough. But the form of ferocious superego activity which Freud noticed is not part of the interesting diffi-culty of the work. It is not part of the struggle all artists have with their material and subject, and has nothing to do with the actual engineering of art. It is outside it, throttling it before it begins, telling the writer that she must always produce brilliant work and that she can-not make mistakes, endure failure or even success. The superego is only destructive.

Why would anyone have such a killing machine inside them, which Nietzsche refers to as 'bad con-science'? For Freud, one of the most fascinating and impassable enigmas was people's self-destructiveness, their masochism and their sadism. Indeed, he called this death drive 'mysterious'. And you only have to lis-ten to yourself to witness it.

The ears have no lids. It is not just the notionally mad who hear voices. Who isn't possessed by them? The superego isn't just an obscure psychical function, it is more like an involuntary voice of command, involving a threat which states that if you think or do a particular thing, you will be punished. And imagined punishments are usually awful.

Not one of us didn't spend years of our young life under the command of others, an order of adults which guaranteed our safety. It is important not to forget the sheer amount of fear all children endure. So the origins of this ever-present threat are our parents and other authorities, plus the fury we felt about their instructions, particularly since we believed they secretly enjoyed torturing and mistreating us.

This conjunction resembles the creditor/debtor dyad, the distinctive relationship of our age. The creation of unpayable debt is a characteristic of the superego; but, as with fascism, it has to promise enjoyment as it works. You get hooked on failure since the superego is always sexualised. It is as if you are in a perverse relationship with yourself, where pleasure, as a last resort, is extracted from suffering.

This internal social order is a narrow sharia-like zone within which disruption and unpredictability – speaking or writing freely – is continuously punished. It is hard work being an oppressed victim of your own internal savagery. Parent-like, the superego appears to provide a form of protection, a limit, a boundary to what might be experienced as a spiral of endless pleasure. But this promise of stability is of less use to the adult artist, who must work with uncertainty, clearing a path for the new. You're in a dark forest with just a torch, stumbling about. If you know what you're doing, it isn't art.

The superego is always busy, working where and how it can. Not only concerned with prohibition, it is, Janus-faced, also a devil of temptation, pushing us to go further, to enjoy wildly, while telling us that we can never have enough pleasure. Like capitalism, it wants us to consume continuously and remain unsatisfied. Excess can never be excessive enough. Whichever way it looks at us, and whatever it says, we always fail.

Liberating oneself from self-slavery and self-reproach can never be a permanent achievement. But good things do get done: terrors are overcome, guilt is borne and these vindictive 'persecutors', or self-created phantoms, are chased away, at least for a while. If we have some intimacy with ourselves, it is possible to track these harassers and wrestle with them. Insults are not truths; intelligent resistance can trump the addictive enjoyment of self-persecution.

The return will be a clear channel of good communication between instinct and judiciousness. This is where the work is achieved, not in discipline, but in enjoyment, passion and desire – art made in pleasure as a gift for others.

Read My Mind

I was surprised to read recently that the three most desirable occupations in Britain are considered to be those of author, librarian and academic, all of which involve books and writing. Yet writing is such an old-fashioned idea. Are people still doing it? And even reading? Do they still bother?

Although many of us wanted to be footballers or pilots, most of us – at least those over forty – can say that we have been altered by what we read. Books represent and change the way we think, particularly when we are adolescent, because it is in stories that we are groomed by the future, seduced away from our parents and the constrained world of our childhood to make contact with more ideas of how to be a person. It is like finding a new lover and losing your balance as the future opens up.

For at least a generation we have pursued money for its own sake and failed to create more significant meaning, living in a materialistic medium with a limited idea of what we human beings can be or do. Now we offer our children little in terms of creative possibility. Hyper-competitive, ruthless, fast-paced, this is a cynical age of

alienation where fundamental alteration seems impossible. We are shocked and disturbed when young people become idealists or revolutionaries, but it is not, after all, such an anomalous, unprecedented thing to want to make a new society. Our own ideals – to become rich, powerful, not a loser – are beyond most people, and they serve not as useful models, but as means of torment, creating a paradise of indulgence where everyone is dissatisfied.

One of my writing students found herself in a tangle because she wanted to write 'good, positive' characters, people who were politically engaged, standing against the greed of the age. It was not a fatuous idea, but her virtuous and blameless people were unconvincing. They bored her too, though she didn't know why. I said it's strange, but audiences enjoy characters like Iago, Hannibal Lecter, Romeo, Homer Simpson, Portnoy and Hedda Gabler. They admire sharp-tongued women like Dorothy Parker or Mae West, writers like Sylvia Plath and Jean Rhys, and actors like Bette Davis and Jack Nicholson. These characters are popular because the public can identify with their transgression and the amount of enjoyment they get from it.

It isn't as if we secretly despise good people or really want to be monstrous. But we do relish the gratification that disobedient characters enjoy. Murderers, criminals, even weaklings and sexual predators yield us entertainment in literature, theatre and the cinema because of

their rebellion and their drive. And when characters lose themselves in their desire for satisfaction, and since we can all be overwhelmed and disturbed by pleasure, it is also where characters reveal themselves the most.

We identify with their alternative morality as they cross lines we'd never dare approach. These characters aren't undecided about things; they don't care; they are freer than us. They are usually punished too, which contributes to our satisfaction: the world is re-balanced. We are not in a hellish, never-ending spiral of wild enjoyment.

The contemporary version of super-fast capitalism orders us to consume continuously: eat well, not get fat, go to the gym, look like movie stars and have great sex. Yet, ultimately, this enjoyment is unavailable to us because, like the anorexic, we always fail. The ideals of our society – celebrity, power, wealth – are necessarily beyond us. Far from living in a paradise of indulgence, we are in a waiting room of deprivation, deferral and suspension, while even corrupt politicians, immigrants and religious fanatics are all, apparently, having more fun than us. There's more of everything but less satisfaction.

Meanwhile slavery is increasing. Many are enslaved to others; most of us in the West are slaves to a crueller, if not more vicious, part of ourselves, which seeks sovereignty over our more interesting selves. This part is politicised since in the working world you are compelled to present an assured, autonomous self which

is adapted, indeed submissive, to the social order. The requirement is of sacrifice and control; to succeed you must become a puppet of the system. This applies even to the rich, who are also subjected to the system and can never achieve the security they believe wealth will bring them. They are debt-slaves too. Always waiting to be safe, their insecurity will increase. They will never stop suspecting that the lazy poor are stealing from them.

It isn't surprising that people have turned to mindfulness or meditation, to re-design themselves to bear repetitive, pointless activity with a regular mind. Meditation can be useful for those with anxiety, but there is no exchange of speech, limit or moral transformation involved in sitting alone.

The work of writing is an important compromise, between work and pleasure, politics and action, and self-investigation and communication. If we are artists, we are authorities rather than slaves, using creativity to re-think ourselves. The public identifies with artists, believing they're less likely to be dominated by power's definition of who people are. Artists seem freer than most people because they are less respectful of the system – not that it isn't easy to seem crazy when the rules are narrow and any radical act seems eccentric.

It is in writing – engaging with the difficulty of matching words to experience, of finding new words for old wounds – that we learn to speak our own language rather

than that only of our culture, parents or peers. Failure and play is where creativity starts; then the imagination flares, and truth is always a surprise.

Like everyone else, the artist has to go to the market to make a living. Becoming a writer is guaranteed to reduce, if not entirely halt, your income. But however accelerated the capitalist world is, and whatever the future of digitalisation, the making of art still exists in a private, atemporal space. Today it takes the same time to write something as it did a hundred years ago. While sitting alone among your phantoms and waiting to hear what they say, the difficulties, questions and pleasure are the same. To be an artist is partly to re-make yourself as you undo the myths that have misled you. And that is, indeed, a desirable occupation.

The Muse Gave Me a Kiss

In the drawer of the desk I have used for decades there is a notebook wrapped in brown paper which I started in 1964, when I was ten, and had filled by 1974, when I was twenty. It contains a year-by-year list of the books I read, almost all of which I borrowed from several libraries in the area, which I'd cycle to every afternoon after school in the south London suburbs. I'm looking at it now for the first time in many years, trying to remember why I kept it. I suspect I began it for my Cub Scout reading badge and continued because I could never bear to see blank pages in a notebook.

My eldest son was amazed when I showed it to him, and he even turned the pages for a few minutes. 'You were eleven years old and you read eighty-six books in one year!' Yes; I began with Biggles, Enid Blyton, Arthur Ransome and the autobiographies of footballers and cricketers. In the middle I read Nevil Shute, Nicholas Monsarrat, Len Deighton and Erskine Caldwell, writers pretty much forgotten now, as most of us will be. But in 1974, I'm relieved to see that I go out on a high, with Proust, Dostoevsky and Nietzsche.

I was thrilled to have impressed my son at last. Then he added, 'But I guess there was nothing else to do in the evenings.'

The kid was right about that. Yet out of the interminable zombie boredom and restlessness of Bromley – a commuter town placed between the city and the Kent countryside – a lot happened while nothing appeared to be happening. Much of this went into my first novel, *The Buddha of Suburbia*, which, despite the dour reality, I managed to make into a comedy about being mixed-race in Britain during the punk era.

I'd never had the conviction I was cut out for regular work like other men in the neighbourhood. My interesting friends dressed like Jimi Hendrix and went into music. But for me words were *the* lifeline. One morning at school, staring out of the window, it occurred to me to become a writer. Being an artist for a living was surely the loveliest thing! Suddenly the world appeared to open up. For the first time I had an identity and future. I was going somewhere.

All writers are readers first, and I read everything in the two newspapers we had delivered, the *Guardian* and the *Daily Express*. And when I became a paper boy I sat down on the kerb to read those papers at 6.30 in the morning. While eating, I even found myself reading the labels on ketchup jars; and most weekends my father would drag me around second-hand bookshops

on Charing Cross Road, a habit I inherited and still can't give up. Flipping through the book-list notebook I can see that my preoccupations then – literature, politics, sport, philosophy and, importantly, people's passion for one another – are still my preoccupations.

Experience is always too much when you're young, but there were writers who knew how to pin it down and even make it enticing. I wanted to do that. I was looking for something that could be called inspiration, because words come out of other words, and writers come from other writers. Influence is essential, and if you're lucky one day the Muse will deign to give you a kiss, making you race to your desk and stay there, mixing what you've read with reality, to make a new story for others.

She Said He Said

Sushila had been walking in the park when she saw Mateo and his male assistant sitting on a bench. As she approached them, she noticed Mateo was dishevelled in his black suit; in fact, he was very drunk, which was unusual for him at that time of day, late afternoon. She greeted him, kissing him on both cheeks, and he asked if she would sleep with him. Why hadn't they slept together? he went on. They could do it right now, at his place, if she had time. He had always found her sexy but had been too nervous to mention it.

They had known each other for at least eighteen years but he had never spoken to her in this way. She was surprised and tried to seem amused. She had always liked him. Clever, witty, Mateo worked with her husband, Len. His wife, Marcie, was a confidante. They had all gone to the coast together.

The next morning, she saw Mateo again, in the supermarket. Not with his assistant, and not drunk, he came right over and repeated his remarks in almost the same words, adding that Sushila had been with Len for a long time and surely she was bored with him. Women liked

variety, he said, and he was offering some. They should get together, even if it was only once; nothing more need be said.

Sushila kept her temper. She told Mateo that she would never sleep with him. Not in a thousand and one lifetimes. Not ever. If this was his idea of seduction, she wouldn't be surprised if he were still a virgin.

Right away she called Len and reported what Mateo had said on both occasions. Len was pale and agitated when he got home. He asked Sushila if she was okay, then texted Mateo to say he wanted to meet. Mateo responded. He was now out of town. But he hoped Len had some new artwork to show him. Could he bring it by next week? Len had been drawing so well recently; his work had reached a new level.

* * *

Mateo was surprised when Len arrived empty-handed. Where were the new drawings? Four days had passed, and Len was now calm. He had discussed the matter with Sushila and could levelly report to Mateo what he had heard about his behaviour, first when drunk in the park, and then when sober in the supermarket.

Mateo apologised without reservation and asked Len to forgive him. But Len said he didn't think he was ready to. Forgiving, or even forgetting, wasn't the point.

He didn't understand why Mateo – whom Len thought he knew – had behaved in this way. Mateo said that he had no idea either but that it would be best if they put it behind them. Len asked Mateo why he had repeated the offer to Sushila when he was sober and smart enough to know better, and Mateo said he hadn't wanted Sushila to think he wasn't serious, that she wasn't really desired.

Len thanked Mateo for his consideration. After their meeting he walked around the park for a long time, unable to put the conversation out of his mind. Poison develops in silence, he thought, and what had happened pressed on him more and more, until an idea occurred. He would discuss it with Mateo's wife, Marcie. She and Mateo were still married but no longer together, living next door to each other as friends. Marcie had been seriously ill recently, but Len was keen to know what she made of it all, whether she found her husband's seduction attempts ugly, crazy or something else. Maybe he was having a breakdown, for instance. Or was he just an imbecile and Len had failed to notice?

So Len went to see Marcie, who was convalescing in bed. Knowing she had grown tired of Mateo's antics with other women when they were together, he felt it wasn't wrong to tell her what Mateo had said to Sushila. Marcie knew Mateo; she might be objective.

Having relayed the story, he added that during their conversations Sushila had revealed new facts to him,

something important he had been unaware of, that no one had told him. It turned out that in the past two years, Mateo had approached other female friends in a similarly crude way. Susan, for instance, had mentioned her experience with Mateo to Sushila, and Zora also. Maybe there were others. Had Marcie also heard about his behaviour?

Len wanted to emphasise that, as Marcie knew, Sushila was kind, protective and certainly no hysteric. It wasn't like her to make too much of the exchange in the park and the supermarket. But she had been humiliated and demeaned by the encounters. What did she, Marcie, think of it all?

Although she listened, Marcie barely said anything; she didn't even move her head in an affirmative or negative direction. Her self-control was remarkable. Usually, when faced with a gap or silence in conversation, people babble. Not Marcie. When at last Len suggested that Mateo seek therapy and the source of his discontent – this was, these days, the generally accepted panacea for wrongdoing – Marcie said that Mateo had been in therapy for *twenty years*. Evidently these things took time, Len said. They can do, Marcie murmured.

* * *

When Len went home and told Sushila that he had gone to Marcie's place, she was angry with him. He wasn't her representative. Why hadn't he discussed the plan with

her first? She was the one it had happened to. It wasn't even his story. What did he think he was doing?

Len said that there had been nothing light or flirty about Mateo's approach, as far as he understood it. Mateo had insulted *him* as a human being too; he was entitled to take offence and seek an explanation, if not revenge. It wasn't often, he said, that you experienced deliberately inflicted cruelty. And from a friend! His view of Mateo – one of his oldest friends and someone whose advice he had always trusted – had changed for good. The insult was now general. It didn't belong to anyone and it could happen again. Women were at risk. Len would hate himself if he didn't speak out.

Sushila told Len that he was becoming fixated. It had been a lapse. Women had to put up with this kind of thing all the time. Not that she wasn't touched or impressed by Len's concern. But she didn't think Mateo would do it again; he was mortified by what had been said; his regret was genuine and his behaviour had obviously been self-destructive. Len said that self-destructive things were what people most enjoyed doing. Sushila agreed, adding that Mateo resembled a gambler who repeatedly risked his own security. She herself liked rock climbing, which at times put her life in danger. But Marcie would have a word with Mateo. Marcie was the only one who could get through to him. In future Mateo would hesitate, if only for Marcie's sake.

Len doubted that. Nor did he understand how Marcie could just sit there, putting up with the embarrassment. But Sushila said, please, he knew Marcie was ill. It might be a good idea for him to apologise to Marcie for intruding like that. Was he prepared to do that?

Before he could begin to consider this, Sushila went further. She wanted to speak frankly now. Len could be a little conventional, if not earnest at times, in his ideas about love. He could? he enquired. How was that? Well, Marcie was celibate and Mateo, they were coming to understand, might be a serial abuser. Otherwise they could be the model contemporary couple. Despite everything, they were genuine companions with an unbreakable link that he, Len, couldn't grasp. No one had loved Marcie as Mateo had, and Marcie was devoted to Mateo. Even if he did something crazy now and then, which we all did at times, she stood by him. You had to respect that.

Len mocked the idea of a passionless passion. It didn't make sense and was probably why Mateo was frustrated. Assaulting women made him feel potent.

Sushila said she didn't think that was it. But, with regard to Marcie, she wanted to add that often we love others because of their weakness. And if we were able to keep all the crazy people from being crazy, well, who would want to live in that dull bureaucratic world?

* * *

82

They had grown tired of discussing it, there was nothing to add, and the topic seemed to have been dropped from their lives, when, a week later, an invitation arrived. Mateo's birthday was the following week and they were invited to the celebration. Sushila went into town and spent an afternoon looking for a present. She asked Len to promise not to say anything. A party wasn't the time or place. Len vowed to keep his mouth shut, adding that he would sulk a little and maintain his distance, so that friends knew the incident had registered but wasn't killing him any more.

However, once they got to the party Mateo, or at least a man who resembled him, approached Len immediately. Mateo had shaved off his beard, cropped his hair and seemed to have coloured it. Before Len could discover if this was a disguise, Mateo put his arm around Len's shoulder and pressed his mouth to his ear. He wanted to have a word with him, over there, in a corner of the room. Would Len follow him, please?

Len had told the story to many people, Mateo said. Someone in Mateo's office had even mentioned it. Now exaggerated rumours were spreading. Yet hadn't Len accepted his apology and agreed to end the matter? Do you want to stab me in the heart and make my wife weep all night? Mateo said. She did that, okay? She cried after you walked right into her home and bullied her. And my assistant, standing over there, saw what happened in the park. He admits it was messy, but no more than that.

Len pushed him away. Don't fucking stand so close to me, he said. You don't know what you're saying. You're actually a savage. What about Susan, Zora and all the other women?

Mateo replied that everyone knew seduction was difficult these days. In these impossible times, courtship rituals were being corrected. In the chaos, those seeking love would make missteps; there would be misunderstandings, dark before light. Anger was an ever-present possibility. But it was essential that people try to connect, if only for a few hours, that they never give up on their need for contact. Otherwise, we would become a society of strangers. No one would meet or touch. Nothing would happen. And who would want that? Of course, Len was known in their circle to have issues with inhibition. If there was an opportunity to be missed, he'd miss it for sure. Didn't he dream repeatedly that he'd gone to the airport and all the planes had left? At least that was what he had memorably told everyone at supper one night. He was a born misser.

Len told Sushila he had to go out for some air, but once he was outside he didn't want to go back. He felt as if he didn't quite recognise anything any more. The world was stupid, and there was no way around that. He started to walk quickly away but knew that however far he went, he'd have to come back to this, if he could find it.

We Are the Pollutants

The recent furore over Penguin's wise and brave decision to 'reflect the diversity of British society' in its hiring policy and publishing output seems to have awoken the usual knuckle-dragging, semi-blind suspects, with their endlessly repeated terrors and fears. They appear to believe that what is called 'diversity' or 'positive discrimination' will lead to a dilution of their culture. Their stupidity and the sound of their pathetic whining would be funny if it weren't so tragic for Britain. You might even want to call it a form of self-loathing; it is certainly unpatriotic and lacking in generosity.

The industries I've worked in for most of my life – film, TV, theatre, publishing – have all been more or less entirely dominated by white Oxbridge men, and they still mostly are. These men and their lackeys have been the beneficiaries of positive discrimination, to say the least, for centuries. The world has always been theirs, and they now believe they own it.

Some of us have been fortunate enough to force a way through the maze and make a living as artists. It was a difficult and often humiliating trip, I can tell you. There

was much patronisation and many insults on the way, and they are still going on.

We are still expected to be grateful, though those in charge – never having had to fight for anything – have always been the lucky ones. And these lucky ones, with their implicit privilege, wealth and power – indeed, so much of it they don't even see it – are beginning to intuit that their day is done. Before, with their sense of superiority and lofty arrogance, they could intimidate everyone around them. No more.

It was never not a struggle to become an artist, with racism, prejudice and assumption all around, visible and invisible. I remember standing in a room with Salman Rushdie in the early nineties just after *The Buddha of Suburbia* was published, discussing how it could be that we were the only people of colour there; indeed, the only people of colour in most of the rooms when it came to books. And that was the case with all of the culture industries. The first TV producer I ever met asked me why my characters had to be Asian. 'If they were white, we'd make this,' he said to me.

It is not coincidental that at this Brexit moment, with its xenophobic, oafish and narrow perspective, the ruling class and its gate-keepers fear a multitude of democratic voices from elsewhere and wish to keep us silent. They can't wait to tell us how undeserving of being heard we really are.

But they should remember this: they might have tried to shut the door on Europe, refugees and people of colour, but it will be impossible for them to shut the door on British innovation. We are very insistent, noisy and talented.

When I was invited to join Faber in 1984, the fiction editor was Robert McCrum. He was excitable then, and so was I. I couldn't wait to be on his list of writers since he was publishing Kazuo Ishiguro, Milan Kundera, Josef Škvorecký, Peter Carey, Mario Vargas Llosa, Caryl Phillips, Paul Auster, Lorrie Moore, Danilo Kiš, Marilynne Robinson and Vikram Seth. Not long before Salman Rushdie had won the Booker Prize for *Midnight's Children*, and that masterpiece, with its echoes of Günter Grass and Gabriel García Márquez, suddenly seemed like a great opportunity. The world was coming in; what had been a narrow and sterile place was opening up. These books were successful, and readers discovered that they wanted them.

This is not a gesture that can be made only once. It has to be repeated over and over again. British culture – which is the single reason for wanting to live in this country – has always thrived on rebellion, cussedness and non-conformity. From pop to punk, from Vivienne Westwood, Damien Hirst, Zadie Smith and Kate Tempest; from Alexander McQueen to Oscar-winning Steve McQueen, it has been the voices of the young

and excluded that have made British culture alive and admired. It is widely acknowledged that there is no other country in Europe with a cultural capital to match that of Britain, and no more exciting place for artists to live. This is where art and commerce meet. These artists' work sells all over the world.

The British creativity I grew up with – in pop, fashion, poetry, the visual arts and the novel – has almost always come from outside the mainstream, from clubs, gay subcultures, the working class and from the street. Many of the instigators might have been white, but they were not from the middle class, a group that lacks, in my experience, the imagination, fearlessness and talent to be truly subversive.

The truth is, the conservative fear of other voices is not due to the anxiety that artists from outside the mainstream will be untalented, filling up galleries and bookshops with sludge, but that they will be outstanding and brilliant. The conservatives will have to swallow the fact that despite the success of British artists, real talent has been neglected and discouraged by those who dominate the culture, deliberately keeping schools, the media, universities and the cultural world closed to interesting people.

It is good news that the master race is becoming anxious about who they might have to hear from. At this terrible Brexit moment, with its retreat into panic and

nationalism, and with the same thing happening across Europe, it is time for all artists to speak up, and particularly those whose voices have been neglected.

No one knows what a more democratic and inclusive culture would be like. It is fatuous to assume it would be worse than what we already have. The attempt of reactionaries to shut people down shows both fear and stupidity. But it's too late. You will be hearing from us.

It Was So Much Fun

Artists require solitude to get anything done, but that is not all they need. As they work, they might like to believe that they are outside the market, in a private dreaming space. But artists need to engage the public. They have to keep going, and to make a living. They need contemporaries, supporters and collaborators, people who grasp what they're up to, and institutions and networks that carry their work to the world – theatres, producers, editors and publishers.

Matthew Evans, former Managing Director and Chairman of Faber & Faber, knew a lot about this: his father was a writer. And at Faber he provided his authors with stability and support. But he was personally rebellious and anarchic, and that cheered his writers up because his mischievousness and terror of boredom, habit and respectability reminded us what we were supposed to be doing, particularly in the eighties and early nineties, during that period of greatest Thatcherite ignorance, destructiveness and philistinism. Once, later, I said to him, 'I've just been talking to someone who says libraries are irrelevant in the new digital age,' and he replied, 'Did you punch him?'

I recall Janet Frame, played by the exquisite Kerry Fox, saying in Jane Campion's movie *Angel at My Table* that all she wanted, living in New Zealand, was to be published by Faber & Faber. By 2004, during celebrations for the 75th anniversary of Faber, Seamus Heaney told Andrew O'Hagan that being published by Faber was like 'getting a call from God'.

Since the 1930s, Faber & Faber, which Matthew joined in 1964, had been the jewel in the crown of British publishing, a bit like Manchester United and Jaguar. But by the 1970s, though Faber published Beckett, Pound, Auden and Eliot, things were getting a little staid.

Just as the backbone of the Royal Court Theatre in the 1950s and 60s was the talent of the writers who provided meaning and purpose to it, Matthew understood that Faber & Faber was not about finance, marketing or even profit. The publishing house had to be built on the talent of those it published. For him its poets, dramatists and novelists were at the centre of our national life, and were more important than actors, politicians or accountants. The geniuses Heaney, Pinter, Hughes, Plath, Larkin, Kundera, P. D. James, Derek Walcott, Golding, Peter Carey, Škvorecký, Vargas Llosa – and many others – should be well treated in a non-intimidating atmosphere that had to be, ultimately, organised around them.

Matthew was a charismatic man who could lead without being bossy and was ruthless without cruelty. He

had glamour, charm and class. Careless and virtuous, he knew how to behave with everyone. He loved restaurants, booze, gossip, fast cars, good talk, politics and filth. He was louche, moody, good-looking, wore fine shoes and suits, and with a fetching naivety was always keen to open his jacket and show you the label. He played cricket and was sexy like a movie star, with a shy side and a great body, which is something you won't hear said about many publishers. People in the office and all over London were in love with him, and wanted to sleep with him, though some of them were disappointed.

More than anything, he hated to be bored, which was when he might start to make trouble. And he hated to read, though if you dropped into his office, particularly after an exhausting lunch in the Ivy or Worsley, where he did a lot of his business, you might find him with his feet on the desk looking through the pictures in *Hello!* magazine and drinking whisky. One time when I asked him why, since he was my publisher, he didn't trouble himself with the admittedly arduous work of reading one of my books, he replied with unarguable logic, 'For a start, that's what that lazy bastard McCrum [editor-in-chief] is paid to do when he isn't watching the cricket on television. And, secondly, if I read yours I'd have to read everyone's bloody books, and then where we would be?'

The dinners and parties at Faber in the eighties and early nineties were wild; everyone beautiful and brilliant

was invited, and you could believe yourself to be in a Scott Fitzgerald story. The poets, in particular, copulated randomly and vomited where they stood; people slapped one another and fell over; and Melvyn had his head shoved into a toilet by someone or other who hadn't liked a show. Later, everyone would go to the Groucho, of which Matthew was a founding member.

Matthew was loved by the best men, like Seamus Heaney and Ted Hughes, and by the loveliest women, like Caroline Michel, and if he loved you, he'd be loyal for ever, never let you down and sit with you for hours, though he wouldn't necessarily share intimacies or even say a word.

He was too intelligent to take anything over-seriously, but he picked his enemies and only insulted people worth insulting. When he was chairman of the Royal Court, and I was on the board, he clashed with the equally macho and uncompromising artistic director Max Stafford-Clark, asking right out why the plays were neither informative, entertaining or short. John Osborne wrote Matthew the most offensive postcards he'd ever received, often beginning 'Dear Cunt', and Matthew once asked me, 'Is that fucking boring Harold Pinter actually a good writer?' 'I'm afraid he is, Matthew,' I had to reply.

When he was dying, and it was said he was demented, I liked to whisper the names of his most hated foes into his ear and inform him they would soon arrive to read to

him from their latest works. His wicked eyes, even then, would fill with horror as he thrashed in his bed.

You understand, as you get older, that defiant, magnificent people are few and far between. The world was more fun with him in it.

Two years ago, strolling along Copacabana beach with my youngest son, we ran into him, and he had a plastic bag around his arm. When I asked him what had happened, he said he'd got a tattoo. 'It's never too late to be a teenager,' he said.

Starman Jones

One of the first and most important pieces of advice David Bowie ever gave me – and this was in the early 1990s – was to make sure I noted down the names of secretaries and assistants I came into contact with. This would help me later, he explained, when I needed to get through to the important people.

Charm, as Albert Camus put it in *The Fall*, is a way of getting people to say yes before you've told them what you want. And Major Tom, or Captain Tom, as Frank Zappa insisted on calling him when Bowie tried to poach his guitarist, had already used his ample portion of it to get through to the important people. And to the assistants, secretaries and thousands of other women he slept with, sometimes in threesomes and at orgies in Oakley Street in Chelsea, where he lived with Angie Barnett in what was then cutely called 'an open relationship'.

Bowie's father, who knew a lot about music and was an early encourager – perhaps Bowie's first fan – was head of PR for Dr Barnardo's children's homes. In a sense, Bowie himself always worked in PR, realising early that the image was everything. Even as a teenager Bowie had learned to

make both men and women adore him. By his early twenties, he had turned to men for sex, sleeping with mime artist Lindsay Kemp and composer of musicals Lionel Bart, among others. A vivacious Kemp, interviewed by *GQ* editor Dylan Jones in *David Bowie: A Life*, says that Bowie 'went out with most people', including Kemp's costume designer, much to Kemp's chagrin, causing poor Kemp to attempt suicide by bicycling into the sea at Whitehaven in an effort to re-create scenes from both *The 400 Blows* and *Bicycle Thieves* simultaneously.

According to Mary Finnigan, his former Beckenham landlady, and herself another forever disappointed suitor – Finnigan wrote *Psychedelic Suburbia*, a delightful account of her relationship with Bowie in Beckenham, just after he'd left home and had broken up with the splendidly named Hermione Farthingale – Bart swung down to the south London suburbs in his Roller and disappeared with Bowie onto the back seat for the afternoon.

Bowie was an admirer of Joe Orton's cheeky subversion. They both had something of the Artful Dodger about them; Bowie certainly wasn't averse to putting it about when it came to getting ahead. He had much to put about. Feminine and extraordinary looking, with different coloured eyes, a swan neck, porcelain skin, good hips and a delicious penis, he had it all. I believe his penis was initially detailed in print by his first manager Ken Pitt, in *Bowie: The Pitt Report*. Bowie deserted Pitt after

'Space Oddity' became a hit, but Pitt poetically describes Bowie's 'big penis hanging from side to side like the pendulum of a grandfather clock'. Enthusiasts will be pleased that Bowie's member is often commented on by fans and biographers, and might want to think of Bowie as something from a drawing by Aubrey Beardsley, a thin man with a transcendental phallus.

Bowie attended the same school as me, Bromley Technical High School in Keston, Kent, but ten years earlier. It is important to note what a shithole it was: bullying, violent, with incompetent if not sick teachers. Education, in those days, for working-class and lower-middle-class children, was hardly considered essential or even necessary. We were being trained to be clerks for the civil service, like the dour, eponymous hero of H. G. Wells's *Kipps*, a rags-to-riches tale of self-improvement which we studied at school, since Wells was the only famous local artist apart from Richmal Crompton, author of the *Just William* books. The more imaginative boys, or the ones who could draw, went into advertising, which Bowie did after school, working on a campaign for a slimming biscuit called Ayds. The only decent adult at Bromley Tech was guitarist Peter Frampton's dad, Owen, who let us use the art room at lunchtime to mess around in with guitars, while complaining how much he hated Steve Marriott's voice. His son had just joined Humble Pie.

It is instructive to recall how little was expected of us

kids and how we were patronised. I remember a nou-
veau riche friend from 'up London' walking into our
house in Bromley and saying, to Mum's horror, 'What
a lovely little house you have!' British pop has always
been lower-middle-class and came out of the art schools
rather than universities, which was where, until recently,
all the rest of British culture – theatre, movies, the novel
– came from. Pop was always more lively: the music-
mad kids were rebellious, angry and ornery. They always
had a chip on their shoulders when it came to class and
education. Social disadvantage has always been essential
to pop: the hilarious incongruity of kids brought up in
small houses without central heating and eating Spam
for tea suddenly finding themselves living in mansions
after writing a hit song.

Despite Lindsey Kemp's efforts, Bowie was a terrible
mime. But he was a great mimic and loved to do the
voices of his contemporaries – Jagger, Bryan Ferry –
while pissing himself laughing. This matter of the voice
is interesting: as with a lot of us, Bowie's accent wobbled
and never really settled. The accent known sneeringly
as 'mockney', used by south Londoners like Bowie and
Jagger before they went American, would have been
necessary as well as natural at the time for boys brought
up among cockneys who'd moved to the suburbs after
the East End had been bombed during the war. That
accent, which I still do when I'm bad-tempered, would

have helped you fit in, saving you from being beaten up at school or on the street, since the locals weren't keen on anyone who didn't speak like them, or, God forbid, showed an interest in anything artistic. The commmunity was always aspirational, but determinedly downwardly mobile when it came to culture. You wouldn't have wanted the lads to see you in a dress.

Fortunately, Bowie's schooling didn't interfere with his education. Almost everyone remarks on Bowie's everlasting curiosity, 'self-improvement' and wide-ranging intelligence. After reading Robert A. Heinlein's 1953 sci-fi epic *Starman Jones*, as well as collecting from movies, poetry and the numerous artists he admired, he constructed himself and his numerous aliases from a range of sources. As his obvious precursor Oscar Wilde writes in *The Picture of Dorian Gray*, 'Man was a being with myriad lives and myriad sensations, a complex multiform creature . . .'

Bowie was more Don Juan than Dorian Gray, a woman's fantasy rather than a narcissist. It is well known that he made himself up, but much in him remained constant. Unlike Iggy Pop or Lou Reed, or Bowie's schizophrenic older brother Terry, he was born cheerful and was never truly nihilistic or even depressed. Like most of us, he worried he might go mad, but he clearly never did, despite his best efforts. He was unembarrassable and could be blokey and laddish in the English manner,

adoring jokes, TV shows: Larry Grayson, Peter Sellers, Pete and Dud and *The Office*.

Bowie wasn't one to waste anything. Even his period of self-destructiveness yielded some of his finest work, which, like the Beatles', was that incredibly difficult thing – both experimental and popular. He told me that cocaine almost killed him several times, his friends putting him in a warm bath just to keep his circulation moving. However, he was always concentrated and was never not serious about his career. Both otherworldly and extremely practical, when he had a new album, he'd make the terrifying move of playing it to you, sitting opposite you in a kimono with a pad and paper, ready to make notes, seeming to believe he could learn from you.

I met Bowie through a mutual friend and asked if we could use his songs on the soundtrack of the BBC adaptation of my first novel, *The Buddha of Suburbia*. He agreed, and said he also had ideas for some original music. When he was composing this, and I expressed fear that parts of the music was either too fast or slow, I can't remember which, he hurried back to his pad near Montreux in Switzerland, spending the night re-doing everything. He'd never composed for film before: he had wanted to make the score for *The Man Who Fell to Earth* but was too knackered after filming to get down to it.

In his *Bowie: A Life,* Dylan Jones uses a collage or dialogical method, collecting the voices of those who

knew or worked with Bowie and running them together chronologically. It is a pleasure to hear from everyone: lovers, managers, musicians, journalists, Croydon girl Kate Moss, musical figures such Carlos Alomar, Earl Slick, Mike Garson and Tony Visconti. And we hear all the Spinal Tappish gossip. The time Jimmy Page spilled beer on Bowie's silk cushion and blamed Ava Cherry; and when a clearly envious Paul McCartney invited him over and then couldn't bear to talk to him, but got Linda to instead. The time Bowie and John Lennon went on holiday to Hong Kong and were determined to try monkey brains. And how, when Bowie's shows had intervals, he'd sit in the dressing room watching *Coronation Street* on VHS.

More importantly, as a more-or-less single parent, Bowie brought up his son, the film-maker Duncan Jones, impeccably, and it is amusing to think of him and Lennon talking together about being good fathers. Bowie always said that Keith Richards was less out of it than he liked others to believe, being an ace at Trivial Pursuit, for instance, but the same was true of Bowie himself.

Many Bowie stories are as familiar as tales from the life of Jesus, but most impressive about the useful biographical method which Jones uses are the accounts by then youngsters like Nick Rhodes, Neil Tennant, Siouxsie Sioux and Dave Stewart of seeing Bowie as Ziggy on *Top of the Pops* and suddenly understanding something

about their lives and what they would go on to do in music. Bowie appealed to those who wanted to get out of Bromley or anywhere that resembled it – most of Britain in the 1970s. His kids' song 'Kooks' really is wonderful; he was liberating and did want to 'let the children boogie'.

Bowie and Iman came to visit Sachin and Carlo, our twin sons, when they were born, bringing gifts. That night Paul McKenna, who was a pal, tried to hypnotise Bowie into quitting smoking, but he clearly didn't want to be hypnotised and didn't want to quit, but he pretended for Paul. After, I remember him standing on the steps of my house, begging me to get him some fags. 'Can't we go together?' I suggested. 'But I can't go anywhere,' he said, gesturing at Shepherd's Bush.

Being flattered and fawned over your whole life isn't necessarily all it's cracked up to be, and, in his last years in New York, he gave up pleasure for happiness. It seemed he returned to the blessedly ordinary satisfactions of being a good parent and husband. Not that someone like him could give up being an artist; unlike most pop stars, his last albums were a development. If, inevitably, this story is sad at the end – Bowie never seemed the sort of person to die on you – it is inspiring to hear what he meant to so many people.

He always sent a birthday card, which, characteristically, he made himself. He was our starman, and he knew it. He did it for us, always prepared to be the hero

we wanted, a real star, not a musician in jeans and a T-shirt with dirty hair, but a glorious glowing beauty like Jean Harlow, Marlon Brando or Joan Crawford, someone who lived it all the time, and who was never bored or ordinary for one moment. Anyone, anywhere, who has ever listened to pop and danced in their bedroom will have listened to him, and always will.

His Father's Watch

In Georges Simenon's *When I Was Old,* his wonderful journal of the years 1960–1962, which apparently he wrote for his children, and where he is mercilessly honest and shows what an acute self-observer he is, the writer tells us that when his father was dying, he, Georges, felt the absolute necessity of going with a 'Negress'. This was clearly a pleasure of his, since later he would have an affair with Josephine Baker. But on this occasion the notable thing is that he paid for sex with his father's watch, about which, as he tells us, he felt suitably guilty, though not so guilty as not to do it.

Simenon was a great writer who used a cheap or popular form – crime fiction, mostly – to write about important things: theft, blackmail, murder, prostitution, deceit and cruelty. Betrayal – and its necessity, in particular – is a theme of his, because, as he makes clear, none of us are ever far from either being a perpetrator or victim. Security in this world is not an option. All of us are always on the verge of being let down or losing our place.

The other thing about which Simenon remained constant was the market, for which he laboured incessantly

and cheerfully, writing book after book. There were, of course, numerous movie adaptations of his work, as well as TV series and translations. Simenon was no unworldly artist. Stendhal had noted that success required shamelessness, and Simenon understood the market, he was good at PR and he knew how capitalism worked. In 1927, for 100,000 francs, he arranged to write a novel while suspended in a glass cage outside the Moulin Rouge for seventy-two hours. The characters in the novel would be decided by the public. It didn't take place, but it could have; Simenon was aware that the legend was sufficient. But he also knew that one could become trapped inside the legend, and he didn't like to be trapped.

Simenon had an animus against categorisation and was in favour of complexity, particularly when it came to himself. With regard to literary values, he wanted to challenge the snobbishness of the time. Every year, when the Nobel Prize came up, he hoped or sometimes expected to be chosen. Yet he didn't want to write for scholars, critics or students. He wrote brilliantly organised throwaway books for the public, while wanting to be known as a great artist. Somehow he succeeded in doing both. He eradicated traditional ideas of the artist by making pulp fiction into an art form; he wrote fast-moving novels about trashy people, which could be read by ordinary folks, usually in one sitting, perhaps in a waiting room. Or on a train journey.

Like Hemingway and Steinbeck, whom he admired, Simenon went back to the people, writing for them and about them. In his stories he says little about his characters' internal life. They are just people who do ordinary things for a long time, and then, suddenly, something significant occurs which changes them. Simenon read and admired Freud, but he never wanted to be a psychologist in the manner of Stendhal, Flaubert or Proust. After Joyce there weren't many avenues for literary writers to pursue, but Simenon returned good writing to the story, which is where it will always belong. Colette, for whom he briefly worked as a journalist, supposedly encouraged him to remove all traces of beauty or literature from his work. He said, when interviewed by the *Paris Review*, 'I was writing short stories for *Le Matin,* and Colette was literary editor at that time. I remember I gave her two short stories and she returned them and I tried again and tried again. Finally she said, "Look, it is too literary, always too literary." So I followed her advice.'

He learned to 'kill his darlings', as William Faulkner – a writer Simenon also liked – advised. This was a brilliant suggestion. Simenon became a minimalist; he learned to show everything quickly, and, as a result, his work has a relentless energy and straightforwardness: austerity plus speed.

There are perfect sentences, such as, 'It was cold. It was raining. It was slushy.' Simenon, like P. G. Wodehouse,

is admired by all generations of writers as a master, for few writers are as competent with the difficult balancing act of structure and plot, as well as of atmosphere and character. And his *romans noirs*, written in a direct and filmic style, with their nocturnal feel and their crooks, deceivers and marginalised bums, were perfect for the war-torn periods through which Simenon lived. And they have become perfect for us.

Simenon was born in Liège in 1903, and the German occupation of Belgium was probably the defining event of Simenon's early life, when he learned that any ordinary individual might have to cheat, lie, betray or even kill in order to survive. During this time he worked as a journalist and wrote anti-Semitic material for a collaborationist paper. But he didn't want to be a journalist. His head was full of people, and they never went away or left him alone.

At the same time as he was working on *When I Was Old,* Simenon wrote *The Train* – which is also concerned with occupation, and is exquisite in its beauty and simplicity. Set in the early 1940s, it is the story of Marcel, a quiet, ordinary, tender man who mends radios for a living, and who is forced to flee his town with his wife and child when the Nazis invade France. Ordinary people, caught in the wheels of history, can wake up one morning and find they are refugees.

Marcel and his pregnant wife and child are separated. During this time he begins a relationship with a woman

who sits with him on a packed train taking refugees across the war-torn country. This is not a story of sexual desire; it is of a passionate, mind-changing – if not life-changing – love. The point is not that just anyone could have beautiful sex with a stranger, it is that there are worse dangers: one could fall in love with them. Then they could accompany you to disaster. Even worse, you cannot know until it is almost too late if you have unconsciously chosen a partner who will ruin you. This would be one of the darkest temptations, as well as one of the most difficult to resist.

The Train suggests that under certain circumstances war can at least free people from their allotted roles, and Marcel informs us that he has never felt as liberated and vital as when he is fleeing. Out of time, as it were, and freed from habit, the world recovers its savour and a person can feel very pleased to be alive. Simenon sketches the woman lightly, and she is more or less anonymous to Marcel, as he is to her. This not knowing is important; it makes the relationship work. Knowledge would be counter-erotic; there would be responsibilities, debt and inhibition.

There is no doubt that, when he finds his wife, child and new baby, he will reunite with them. Eventually, the family return home, where everything in their small house is untouched, and comfortable habit envelops them once more. The new element in his life is the fact that Marcel secretly begins to write an account of his adventure 'off the rails'. This is intended for the youngest child,

for whom Marcel wants to offer a rounded picture of himself. Therefore the novella itself becomes a kind of memoir, not unlike the thoughts about marriage and domestic life Simenon was writing contemporaneously in his notebooks. Since the truth cannot be spoken or integrated yet, it must be preserved and written down. Someone, sometime, will hear and understand it. But not now.

The Train illustrates Simenon's life-long ambivalence about bohemia and the bourgeois life. The theme of someone leaving one life and descending into another is common in Simenon's work, and often his characters exit their lives to become murderers or serial killers. Simenon calls it 'the moment of downfall'. Yet if we break through the veneer of civilisation, where sadism is disguised as morality, we will find, underneath, another Hobbesian world of competition and cruelty.

But criminals, you could say, are enviably free. For a time the rules don't matter to them; temporarily, they are beyond good and evil. In this uncontrolled zone we know they will perish in the end. But, on the other hand, civilisation is too constraining, and aggression will be turned inwards. Simenon's characters veer between the desire to survive in a mortified but civilised world, and the temptations of life outside of it. They desire both. They can never settle.

In truth, it is civilisation which is truly dangerous, and Simenon, although he was wealthy, successful and

hard-working for most of his life – and lived in large houses served by many staff – was aware of this. He thought of becoming a doctor, but he also believed he could have become a 'criminal', and he confesses in his diary that 'I have made love in the street, in passageways, when the unexpected arrival of a policeman could have changed my fate.' Criminal or doctor: whichever it was, he wanted to study what he called 'man', whom, like Freud, he could only understand through his aberrations.

In common with Picasso and Simenon's friends Henry Miller and Charlie Chaplin, he was neither a full-time bourgeois nor a committed bohemian, and felt he fitted into neither milieu. He liked women, he liked to be married, he liked sex – once, when his wife was packing for a family holiday, he invited four 'professionals' to visit him – and he liked danger and risk. Every book for him was a risk, because when you started a new one you never knew if it would work out. Like a lot of writers, he became depressed when he finished something, and this was when he would haunt the red-light districts of the cities he was staying in, putting himself in danger.

Trains feature in many of Simenon's works, and you could say that the train is a compelling metaphor for the regularity and compulsiveness of his schedule and the scale of his incredible productivity. Simenon never wanted to be considered a Don Juan, but reading accounts of his sexuality in his notebooks I couldn't help but be

reminded of the famous 'catalogue aria' from Mozart's *Don Giovanni*, where the servant Leporello explains to Elvira the nature of his master's classification of women, and the pleasure of adding another name to the account. The list itself is, of course, a niche or specialised form of sexual intensity, and one which often appeals to men.

The excess of libido, the hyperactivity and the counting – the number of women, of novels, of days it took to write them – are notable throughout his life. They were clearly crucial to Simenon, whose father was an accountant, after all. So, among other things, Simenon spent his life counting, and anyone who writes about Simenon is also obliged to take part in the counting and accounting, though clearly it doesn't matter a damn to the reader whether it took the writer days or years to finish a book. (You should know there were around four hundred novels, of which seventy-five were Maigrets. Sometimes he wrote only four novels a year; on other occasions there were eight, or even ten. Rarely none.) It is as if Simenon believed that if he stopped counting, stopped writing or stopped having sex – if there were to be a gap – something catastrophic or, more likely, too desirable would occur. There would be little time for reverie, dream states or uncertainty.

Freud calls libido 'demonic'. Driven by constant pressure, it never rests. When it came to sex, it seems that Simenon was quick but efficient. He describes his thousands of

encounters as 'hygienic', and he preferred prostitutes. 'A professional often gives me more pleasure than anyone. Just because she does not force me to pretend.'

He may have required 'two women a day' and felt like 'a dog in rut', but as a writer Simenon played the other part, that of the 'professional'. Like Chaplin or Hitchcock, who was sly and similarly able to make commercial art for a popular audience, Simenon knew what he was doing. Everything he wrote is dramatic. He was a serious and experienced coquette, the master of withholding. It is both a trick and an art, deferment, knowing how to make the other wait, hang on and want to return. A good writer, from this point of view, is one who creates hope and fascination, using gaps – an absence of knowledge – to trap the reader, playing with his frustration, but never too much. This kind of writing will stimulate anxiety in the reader and then relieve him by providing that which is missing. A plot is a promise delivered, and Simenon knew how to deliver such satisfactions. It always works, and always will.

His books might appear to run like clockwork, and Maigret – that measured and intelligent sensualist – might have healed the world over and over again, but in the *romans durs* there's no easy redemption. These novels are too engaging and compelling to be cold or mechanical. *The Train* isn't like any other book by Simenon or anyone else. Not only is it one of his best, but it is one of the great novellas of the twentieth century.

The Widow

I must have been about twenty-one when my father took me to the widow's house for the first time.

I wasn't keen to hang out with my father, but I guess he was being kind, thinking I should meet people, probably because, mostly, I just sat in his flat trying to write plays and listening to German bands like Amon Düül.

I had imagined, of course, that the widow would be an old woman. And Stella *was* older, probably around forty to my twenty-one.

Her husband, who had once been a colleague of my father's, had died, I guess, about a year earlier. He'd been a lecturer like Dad, but became a well-known and controversial figure, writing some sort of book about sexual liberation, and then marrying Stella, this very wealthy and beautiful bohemian woman, who'd had a fine time in the sixties. Stella's mother had been a painter, and the siblings all looked like film stars. While we were at home in Orpington watching *I Love Lucy*, they'd lived in Italy and France, sunbathing around pools, sleeping with friends, hanging out with bands and acting in Italian movies.

Stella had a lovely house full of books, paintings and sculpture in Holland Park, where the park, to my amazement, had actual peacocks. But Dad and I were on the other side of the roundabout, down in Shepherd's Bush, after my parents had sold the family house and separated. The Bush was like the 1940s then, with its second-hand furniture shops and old-fashioned restaurants with aged men and women eating alone, served by ancient waitresses in black skirts. There was even an eel-pie shop, which is still open.

I was sleeping on Dad's couch, having dropped out – or rather, fallen out – of university. I felt unnoticed, invisible, and was paralysed with depression.

But one afternoon Dad and I sat across the table from her, the widow who never wore anything but black, and who even had 'widow-black' dyed hair. I couldn't stop staring at her. She acknowledged me with a Mona Lisa smile, but had too much taste to look at me twice. Except, as we left, she said to my father, 'He's an interesting young man.'

'He is?' said Dad, rather surprised, standing back and looking me over as if he'd never seen me before.

The next day I called on her and we became lovers.

It was mostly her beauty which appealed to me. But always willing to be of use, perhaps I hoped I might cure her of some of her sadness.

My enthusiasm might have also been because my dad idealised the sixties. He'd tell me how lucky I was to have

been born after the 'revolution', as if, before it, there was only air raids and tinned fruit. But by the middle of the 1970s the sixties had gone, and London, as the Clash were informing us, was pretty bleak, even if you were on the dole, as I was.

I thought Stella might educate me. And she did play music constantly, but only the saddest. Mahler, and Verdi's *Requiem Mass*, over and over, and pianists like Richter and Rubinstein, until I knew every note. And she lay in bed reading Baudelaire, Huysmans and Genet in French, and Proust in English, because, apparently, it had become better written in the Scott Moncrieff translation. As she finished each volume, she'd fling it over to me. I had no choice but to read for the first time in my life. She liked to talk about the characters – Swann and Odette in particular – as if we knew them.

These days my idea of bliss is to go to my local café at the end of the afternoon, order a bottle of wine, and read. I can get through a book a day. Reading is something you don't need a woman for.

But there was something I liked and needed then.

'Come and see to me, darling,' Stella would purr, as soon as I turned up.

In my fantasy the person she resembled was Charlotte Rampling – thin, upper-class and wildly superior, with her languages, taste and ability in the world.

After Bowie moved to Berlin, my mates and I, who

were beginning to form bands, watched *The Night Porter,* *Cabaret* and *The Damned.* I particularly liked anything with Helmut Berger in it. I'm ashamed to say I kept a picture of Helmut Berger in my wallet. Can you imagine, I also saw *The Romantic Englishwoman* several times.

It seems improbable now, but in those days, if you wanted pornography, you went to art. And, for me, cinema was the form which best dealt with perversion. In those days I believed perverts had the most enjoyment, and for my crowd that meant brothels, uniforms, prisons, *Venus in Furs* and peroxide hair.

And Stella, I was discovering, was a lovely perplexity. Her husband's cigarettes and glasses were on his desk, his jacket was on the back of his chair, his shaving stuff in the bathroom. There were photographs of him in every room.

I saw that the two of them had travelled, and he'd lectured to big crowds on fashionable subjects.

I had walked in on a death. But now she was with this kid – me. She was my girlfriend.

'Do you like cunnilingus?' she had said on the first day.

Now that is a question you're not often asked, I find. And one you could profitably hear with more frequency, in my opinion.

'I love the lingus, lots of it,' she announced.

I was to put my face at her cunt and lap away, a licking, salivating love puppy, for a long time, while at the other end, as it were, she smoked roll-ups, sipped whisky

and sang. 'You doing that,' she said, 'is like having a Bach fugue played on one's body.'

I was happy every day with my work as an 'erotic linguist', but I spent the night with her only twice. That was enough, as she drifted around the house in a black kimono, weeping loudly and smashing her fists and bumping her head on the walls. I'd never heard anything so stricken and had no idea how to comfort her.

But Dad, who had begun to consider me a hopeless case and referred to me at home as the 'invalid', was impressed and furious that a woman like her would want to bang me.

'Jesus, son,' he said, when I came back one morning. 'What are you playing at? I was planning on getting in there myself, but thought I'd leave a tasteful interval.'

'That was a bit slow of you then, wasn't it, Dad?' I said.

He said, 'But you can't really satisfy a woman like that, can you?'

'It seems I can, Dad,' I replied. 'She gave me a first edition of *Last Exit to Brooklyn*.'

'I'll have that in lieu of rent,' he said.

Dad became keen that I move in on Stella, with a view to a quick marriage. He seemed to think I might get my hands on some of her fortune, as his friend had, the dead husband. Dad considered money – since he didn't have any – to be far more important than sex or love. He was also sure that I'd annoy this grand lady so much that in a couple of years she'd pay me to get out.

But I was becoming disillusioned. She had seduced me but I had not seduced her. And although in my love work I had learned to use a side-to-side motion, as executed, apparently, by virtuoso Romanian folk musicians, my tongue had become blistered and swollen, as worn and spoiled as a pub carpet. No one could understand anything I said.

I complained to Stella, and one evening we got dressed up and she took me to a first night at Covent Garden. After, we went to a party, where she introduced me to a young man, around the same age and height as me. He said, 'Are you seeing Stella too?' 'Yes,' I said. 'Are you?' 'Yes,' he said. 'And so's he.' He pointed to another little guy.

It turned out there were several other 'brothers of the tongue'. I wondered if we lickers worked in shifts. I'd go to the house in the afternoon sometimes and she wouldn't open the door. I was put out, but cheered up by the fact that I had, as the other kid put it, 'priority'; though when he asked if I 'exercised' my Stradivarius of a tongue at all, I thought things had gone too far.

I was beginning to see what her decadence meant – lethargy, an inability to grasp what others' lives might be like. This was not only her mourning, but her class.

But, because of her, I had begun to know something about fulfilment, or mutuality. After all, I'd been fascinated by her, and loved her beauty and her history, the stories about her mother and nights in Soho with the

artists. But she had no interest in me, apart from as a functionary in a perverse scene, repeated over and over, a photograph rather than a film.

One afternoon she was asleep after a drinking session. I needed to write a review of the Slashed Curtains gig for *Time Out*, who were employing me a bit.

Stella woke up and burst in on me sitting at her husband's desk, hitting his typewriter, scratching away with one of his Mont Blancs, his ink open. I was smoking one of his Gitanes and cheerfully humming along to his copy of 'So Long, Marianne'.

She screamed, 'I was dreaming and I thought it was him, returned to me, sitting there! And it was just you! Only you!'

Underneath she was a violent madwoman, and she began to kick and punch me. She chased me around the table, up the hall and through the front door. I ran away with a bruised face.

Dad, as insatiable as the widow and more vulgar, was smug and contemptuous when he cleaned me up. 'Thank God it happened to you rather than me,' he said. Then he said he thought I was so daft I'd amount to nothing more than a journalist.

'That's what I will be,' I said. 'And one day I'll write about that poor woman, and the idea that if the living are a pain, the dead can be a damn nuisance.'

Travelling to Find Out

One night, my friend Stephen Frears and I went on a boat trip down the Bosporus with about a dozen models, several transvestites, someone who appeared to be wearing a beekeeper's outfit as a form of daily wear, the editor of *Dazed and Confused*, Jefferson Hack, and Franca Sozzani, the late editor of Italian *Vogue*, plus other fashionistas. We were in the European capital of culture, but it was like a fabulous night at the London club Kinky Gerlinky transferred to Istanbul and financed by the Turkish Ministry of Culture.

At one end of the boat, in his wheelchair, was Gore Vidal. At the other end was V. S. Naipaul. It must have been June 2010 because I remember catching Frank Lampard's 'ghost goal' against Germany on a TV in the hotel lobby just before we dashed out.

As the high-tech drum and bass beat on, and the Ottoman palaces drifted by, we godless, depraved materialists and hooligans became more drunk, stoned and unruly. Vidia, with his entourage, kept to his end of this ship of fools, and Vidal to his. We had been instructed to keep the two aged warriors apart, and I

125

don't believe they exchanged a single word during the four days we were in Turkey. Vidal was accompanied by two 'nephews', strong young men in singlets and shorts who took him everywhere. He was unhappy, usually violently drunk, occasionally witty, but mostly looking for fights and saying vile things.

Vidia, in love and cheerful at last, accompanied by his wife, the magnificent Nadira, remained curious, ever observant and tight-lipped. Earlier, despite his supposed animus against female writers, he had been keen to talk about Agatha Christie and how fortunate she was never to have run out of material. In contrast, from a 'small place', he himself had had to go on the road at the end of the 1970s, to explore the 'Islamic awakening', as he put it. He had been 'travelling to find out'.

Nearly thirty years earlier, I had packed Naipaul's *Among the Believers* in my suitcase, and turned to it as a kind of guide, when I first went to Pakistan in the early 1980s to stay with one of my uncles in Karachi. I wanted to see my large family and get a glimpse of the hopeful country to which another uncle, Omar – a journalist and cricket commentator – had gone. Like my father and most of his nine brothers, Omar had been born in India; he had been educated in the US with his school friend Zulfikar Bhutto, finally turning up in 'that geographical oddity' Pakistan in the early 1950s. He said in his memoir *Home to Pakistan*, 'There was in the early Pakistan

something of the Pilgrim Fathers who had arrived in America on the *Mayflower.*'

At night, alone in a backroom of my uncle's house, I suffered from insomnia, feeling something of a stranger myself. In an attempt to place myself, I began to work on what became *My Beautiful Laundrette,* writing it out on any odd piece of paper I could find.

In Britain we were worried about Margaret Thatcher and her deconstruction of the welfare state, of which I had been a beneficiary. I wanted to do some kind of satire on her ideas, but in Karachi they barely thought about Thatcher at all, except, to my dismay, as someone who stood for 'freedom'. My uncles and their circle were more concerned with the increasing Islamisation of their country. Omar had written in *Home to Pakistan,* 'There is an appearance of a government and there is the reality of where real power lies. I had serious doubts that we would become an open society and that democracy would take root.'

Zulfikar Bhutto had been hanged in 1979 and his daughter, Benazir, was under house arrest just up the street, at 70 Clifton Road, a property with a huge wall around it, and policemen on every corner. One thing was for sure: my family, like the nation's founder Jinnah, had envisaged Pakistan as a democratic home for Muslims, a refuge for those who felt embattled in India, not as an Islamic state or dictatorship of the pious.

Naipaul, who in the late 1970s travelled around Malaysia, Indonesia, Iran and Pakistan, had grasped early on that this distinction no longer held up.

Surprisingly without preconceived ideas, and with a shrewd novelist's eye for landscape and individuals, in *Among the Believers* he interviews taxi drivers, students, minor bureaucrats and even a mullah. He writes down what they say and mostly keeps himself out of the frame. As a teenager I had been a fan of what had become known as personal journalism, of fire-cracker writers like Norman Mailer, Tom Wolfe, Hunter S. Thompson, Joan Didion and James Baldwin, imaginative writers who included themselves in the story, and who often, as with Thompson, became the story itself.

Naipaul, in one of the first reports from the ideological revolution, was doing something like this. But he was more modest, this writer of loss and restlessness. From Chaguanas, Trinidad, 'small, remote, unimportant', he travels widely now, has an extensive look around and actually listens to people – mostly men, of course. He never interviews anyone as intelligent as he is, but he is genuinely curious, a rigorous questioner and not easily impressed. He even greets one subject, in his hotel room, while wearing 'Marks and Spencer winceyette pyjamas', of which he is so proud he mentions them twice.

Around the same time, Michel Foucault – more leather than winceyette – visited Ruhollah Khomeini outside

Paris, and went to Tehran twice. Foucault, fascinated by the extreme gay lifestyle he found in San Francisco, had also written for the *Corriere della Sera*, defending the imams in the name of 'spiritual revolution'. This inspiring revolt or holy war of the oppressed, he believed, would be an innovative resistance, an alternative to Marxism, creating a new society out of identities shattered by domination.

It *was* new. But, as Naipaul discovered, there was very little spirituality in this power-grab by the Ayatollahs. Soon they were hanging homosexuals from cranes; women had to wear the *chador*. In Pakistan women now covered up before they went out, and no one in my family had been veiled before. One of my female cousins revered Ruhollah Khomeini – 'the voice of God' – as an example of purity and selfless devotion. He was everything a good man should be. But she took me aside and begged me to help her children escape to the West. Pakistan was impossible for the young; everyone who could was sending their money out of the country and, where possible, sending their kids out after it, preferably to the hated but also loved United States, and, failing that, to Canada. 'We want to leave this country but all doors are shut for us, we do not know how to get out of here,' she wrote to me. 'Fundamentalism offered nothing,' Naipaul states; he didn't find much to idealise.

The characters Naipaul is drawn to want more, but they don't know what it is. Aware of their relative deprivation, they are gullible like Mr Biswas, a sign-painter,

in Naipaul's masterpiece *A House for Mr Biswas*. Biswas becomes a journalist; he is working on a story called 'Escape'. But he is too intelligent for his surroundings. He becomes hysterical, endlessly dwelling on his wounds and victimhood. He is under a power, that of colonialism, which will always humiliate him, and he has internalised that contempt. However, there is one way out: the belief that at least your children will have better lives than you.

Vidia Naipaul appears to be the clever boy Anand in that novel, the one who would escape to Oxford, work for the BBC and become a writer. Naipaul had done all that, but had also learned that you can't escape the past. Now travelling in places like those he came from, in *Among the Believers* he finds a proliferation of anxious, wounded men like his father, whose sons would turn to a new machismo, a politicised Islam, 'because all else had failed'.

Among these sons was my cousin Nasrut Nasrullah, whom Naipaul ran into. Then a journalist for the *Morning Star* with a 'fruity voice and walrus moustache', Nasrut tells Naipaul, 'We have to create an Islamic society. We can't develop in the Western way. It is what they tell us.'

Around the time of the Iranian revolution Bob Dylan released a single, 'You Gotta Serve Somebody', which elaborates on the impossibility of not being devoted to someone, or something. Similarly, seeking a space outside of

the colonisers' ideology, Naipaul's subjects in *Among the Believers* could only repeat – only this time more harshly – what had already been done to them. That which began as an indigenous form of resistance, cheered on by some Parisian intellectuals, soon became a new, self-imposed slavery, a self-subjection, this time with an added masochistic element: Osama bin Laden's devotion to death. Hence the helplessness and disillusionment that Naipaul found. If the coloniser had always believed the subaltern was incapable of independent thought or democracy, the new Muslims confirmed it with their submission to the Ayatollah. They had willingly brought a new tyrant into being, and he was terrible, worse than before. One of the oddest things about being in Karachi that first time was how often people said to me they wished the British would return and run things again. There were many shortages, but that of good ideas was the worst.

A few months after the Bosporus boat trip, Naipaul was invited to Turkey again, to address the European Writers' Parliament, an idea of José Saramago's. This time there was uproar: Naipaul was said to have insulted Islam after saying in an interview, 'To be converted you have to destroy your past, destroy your history.' Naipaul never returned to Turkey, where now, as we know, there are more than three hundred journalists and writers in jail.

Legitimate anger turned bad; the desire for obedience and strong men; a terror of others; the promise of

power, independence and sovereignty; the persecution of minorities and women; the return to an imagined purity: who, seeing the reality of those first years in Pakistan, would have thought this idea would have spread so far, and not only that, would continue to spread?

Why Should We Do What God Says?

It was the early months of 1989, and they were becoming strange days indeed. It's not often you see two policemen on their knees looking under your bed, glancing into your wardrobe and dragging aside your shower curtain to make sure there's no terrorist waiting to spring out and strangle a novelist who's popped round for a drink. But in the north of England bearded Pakistanis were buying books in their local Waterstones before setting fire to them; and a foreign government had just pronounced a 'fatwa' – whatever that was – on a writer for a wild piece of post-modern prose concerning migration, the breakdown of belief, multiple subjectivities and the chaos and derangement of capitalistic acceleration.

As if that wasn't enough: with the cops sniffing around, you couldn't even smoke a joint in your own living room. Luckily Salman assured me that the policeman wouldn't leap up and handcuff me since he really had no sense of smell, even as he tucked into a large plate of my girl-friend's lasagne.

Then, one morning, the Labour MP for Leicester East, Keith Vaz, whom I knew a little – a polite man, he'd

introduced me to his mother in the House of Commons
– called to say we could rely on his support for Rushdie
until the end. That night I glimpsed him on television
leading a march in his constituency against the novel.
You'd have to say that realism was getting very magical in
a black sort of way; and one of the problems with reality,
as *The Satanic Verses* points out, is that it is always being
invaded by unreality: sleep and wakefulness can segue
into one another, and that which we believe is solid can
melt in a moment. And, of all things, the novel, *a novel*
– probably the form which most lends itself to the explo-
ration of human complexity – had become the site of a
world-wide controversy.

A few days later, I was sitting with Harold Pinter in a
pub near Downing Street and we were trying to work out
what to say to Thatcher if she happened to be in when we
passed by with our statement about protecting novelists
from intimidation by foreign governments. To our relief,
Thatcher wouldn't meet us, but creditably she did say,
'There are no grounds on which the government would
consider banning the book.'

Unfortunately my father saw me on television wan-
dering around outside Downing Street and nearly had
another heart attack. He had worked in the Pakistan
High Commission for most of his life and had warned
me that Muslims could become more than agitated if
provoked about the Prophet. During Ramadan he had

to eat his sandwiches behind a tree in Hyde Park for fear a colleague would spot him breaking the fast. Now he rang me up yelling that I should keep out of 'the fatwa business'.

Dad had admired the way Jewish writers and artists had flourished in the West. Philip Roth had run into some community trouble with his great Portnoy, but once he became admired and famous everyone shut up and claimed him as a literary hero and truth-teller. Dad said Jewish children were part of Britain: they were westernised without forgetting their heritage. Why couldn't we as a migrant community do that? Why were we going the other way?

What, I wondered, was the 'other way' my father referred to? What exactly was going on? What was this 'return' and where had this new political and moral fervency come from?

If my friends and I as a generation were surprised and even amused by the fatwa and the level of fury *The Satanic Verses* was provoking, perhaps we boomers had become inured to outrage, insult and provocation. A turd in a tin, a pile of bricks, copulation in an art gallery, dirty nappies, menstrual pads: not a flicker did they raise among the sophisticated. Outrage was style; it was what we expected before we went out to supper. Soaked in drugs and exhausted by years of random copulation, maybe nothing much registered now and we were jaded

after decades of hectic, nihilistic rock 'n' roll and consumerism. The Berlin Wall had fallen; Soviet Marxism was over. Perhaps it was true, as some intellectuals like Francis Fukuyama suggested, that it had been the end times, and we'd really been living in the best of all political worlds.

Not only that, hadn't novels and their authors been pointlessly condemned before? D. H. Lawrence, Henry Miller and Vladimir Nabokov, among many others, had been pursued and prosecuted. And seriously, had anyone become morally worse after reading *Lady Chatterley's Lover* or *The Tropic of Cancer*? There was nothing about banning and prohibition to suggest that it wasn't a waste of time and money. As the years passed, these attempts at censorship looked even worse than they had at the time. More recently, for instance, the Sex Pistols – on the yellow press's front pages for weeks – had been more pantomime and PR than subversion.

Despite this, who doesn't recall that at the time of the fatwa a lot of the media noise concerned Western liberals, intellectuals and even novelists calling for the book to be withdrawn or not published in paperback to protect the feelings of 'insulted' Muslims, though it was doubtful that these people had ever met a Muslim, let alone one who was insulted. Richard Webster, for instance, in *A Brief History of Blasphemy* (1990) writes about *The Satanic Verses*, saying: '. . . its reception and defence by

liberal intellectuals had seemed to give a kind of moral licence to racism which had always been latent.' John le Carré said: 'My position was that there is no law in life or nature that says great religions may be insulted with impunity.' Roald Dahl wrote to *The Times*: 'In a civilised world we all have a moral obligation to apply a modicum of censorship to our own work in order to reinforce this principle of free speech.'

What made them think that this heterogeneous 'community' had only one idea of this? And you could only wonder: if they wanted to give way on Rushdie, what other censorships would they end up favouring? This group were not unlike Soviet fellow-travellers – useful idiots – with little idea that their naivety and wish to side with the underdog was protecting a murderous and authoritarian ideology which they wouldn't want to live under for a moment. According to this elite form of colonial patronisation, free speech was only for the select few; the poor and benighted – as they were seen – couldn't deal with, or ever require, satire, criticism or scabrous story-telling. The book-burners and censor-mongers weren't adult enough to think about simple but essential questions: why should we do what God says? And when is obedience a good idea, and when is it not?

More importantly, it didn't occur to these so-called liberals that the insulted book-burners and putative writer-killers whose feelings they were keen to protect

might end up inflicting immeasurable harm on their own communities, eventually promoting a Salafi version of Islam which was not only a betrayal of religion, but of women, minorities and most Muslims who had come to the West to make a better future for their children. If my father had been surprised by how *English*, as he put it, we, his children, had become, that was the price he knew he had to pay for the opportunities he'd got on the boat for.

If these weak and guilty liberals didn't like the idea of people being insulted – though one always chooses to be insulted – it might have been advisable for them to fight the ubiquitous racism their society generated rather than shutting down a fellow artist who was asking important questions about migration, identity and the sort of world being created by the market economy. Rushdie had touched on the untouchable, and was saying the unsayable. That, after all, was the point of serious writing, though not the sort of writing his literary detractors – thriller writers and children's entertainers, mostly – were capable of.

One more thing: what exactly had Rushdie touched on with his critique of Islam? What was the unsayable? The fury he had aroused guaranteed, it occurred to me, that he had spoken aloud the deeply forbidden thing: the doubts of many believers. Surely the people who most infuriate us, the ones we most hate, are those who create

the most conflict in us? Doubt, disbelief and transforma-
tion were intolerable to those who'd moved to a new land.
To be a migrant was to have your implicit beliefs tested
every day against another paradigm, and doubt could
bring with it a total loss of one's bearings. Some of those
who suffered this wanted to kill the messenger.

The time of the fatwa certainly politicised me; many of
us from Muslim, immigrant backgrounds had to rethink
our identity and politics. Who exactly were we in the
new country and what did we want to be? Why was it so
difficult for us to get on? And, importantly, what were we
even called?

For most of my life immigrants and their children
were mostly known as Asian, a term vague and inac-
curate enough not to be as offensive as some of the
other words used about us. Now, organised around
the fatwa, the religious designation Muslim began to
emerge. It had barely been used in the West before;
now it became common. Looking back, I can see that
this was a fatal identification and misstep, giving rise to
the false idea that we were a unified religious commu-
nity who all believed the same thing and, not only that,
were separate from other minority groups who were in
a similar position in Britain. Even in Pakistan recently
a gay friend said to me, 'They call us Muslims and we're
not even religious! They think we all believe the same
thing! We've been boxed in.'

After the fatwa, in the early 1990s, when I began to research the novel which became *The Black Album*, I noticed that the young Muslims I met were not interested in Rushdie or literature at all; and we barely discussed free speech. Even worse, I realised, no one had thought to interest them in Britain, and certainly not in the Britain I'd loved, of the 1960s and 70s, of fashion, theatre and dance, of drugs, dissent and the fascinating counter-cultural churn of ideas: feminism, patriarchy, sexuality, class. Where had they been all their lives? Who had educated them?

Those whom we once called 'fundamentalists' had become Islamists, and they didn't require tools to think with because they knew already what they wanted. They weren't superstitious, benighted former villagers, but scientists, professors and A-grade students. And what they were involved in seemed more like a cult than a religion. They had submitted to God, so they said, and were keen to have others submit to them. They'd moved beyond the usual rules of sociability, and weren't people you could debate or engage with. They would sneer, harangue and intimidate. That, apparently, was their policy. It wouldn't be difficult for them to colonise and impose their ideas on a heterogeneous and vulnerable community. Where, I wondered, were the more balanced, older people in the mosques, schools and colleges?

Ultimately this group wanted to recruit believers to

help them make a political return to the centuries after the Prophet had died. They even promised, as a vanguard, to create a state based on the strict, macho-fascist Salafi principles that Isis would later adopt. (I call it fascism because fascism always uses ideas of purity, sacrifice and return, alongside the promised elimination of a particular group, as fundamentals.) This notion was a perfect compromise for this relatively small group of paranoiac men bursting with revolutionary fervour. They would, as young people have to, betray their parents, but only in this particular way: by being morally more severe. It was a return, but it was a new form of political religion.

I remember thinking of them on the day of the London '7/7' bombings, in 2005, when fifty-two people were killed. Three out of four of the terrorists were under the age of twenty-two, and three of them were the sons of Pakistani immigrants. They had, apparently, been inspired by the lectures of the Yemeni-American imam Anwar al-Awlaki, who had also preached to three of the 9/11 hijackers, and was known to be charming and articulate.

We know now that the Jewish poet Heinrich Heine was right: that those who begin by burning books end by burning people. Salman Rushdie wrote a good book and couldn't have predicted the furious outcome. But we know that what the Bradford book-burners and Islamists should have seen was that Islamism was never going to be a theology of liberation. Their actions have been

a disaster, contributing to the rise of an active, virulent, fascistic right in Europe, one that condemns minorities and wants to reaffirm a Judeo-Christian future. The creation of the phantasmic figure of the Muslim – to which religious fanatics have stupidly added much colour – is used to justify an increase in prejudice, racism and hate unlike anything I've seen in my lifetime.

Now the community has to fight on several fronts: to detoxify itself, get up off its knees and open itself to better ideas from a range of voices, particularly women and the young. It has to join with other groups to fight against racism. None of this is impossible. Fascism doesn't evolve, it's always the same, but immigrant communities and their children change every day. They should be horrified by the image of themselves which has been created. The part of multiculturalism which is essentialist – limiting groups to a parade of 'authentic' dances, exotic clothes and practices – has also to be fought. The message of the Enlightenment is that we have some choice over who we want to be, making our own destiny as individuals, without submitting to gods, revelation or ancestors. The basis of this is a liberal education and a democracy of ideas. These are not British values – over which Europeans have no monopoly – but universal ones.

There's no doubt that the fatwa was one of the strangest and most significant events in literary history. But what should it continue to remind us of? I can recall, at the end

of the 1990s, seeing Rushdie being interviewed on television, where he said something like, 'Fundamentalists lack a sense of humour.' This remark struck me as important, encouraging us to notice that the greatest works of literature are often comedies, and that comedy is a vital value, particularly when it comes to mocking privilege, power and dogma. The fundamentalists of the time, and the Islamists who followed them – whether part of Al-Qaeda, Isis or one of the many other groups – have intimidation, humiliation and the desire to shut people up in common. We should not fail to notice that many of the Islamists' attacks – on Rushdie himself, film-maker Theo Van Gogh, *Charlie Hebdo* and music venues and clubs – are attacks on cultural pleasure, playfulness and sexual freedom.

Novels and other forms of story-telling might present, analyse and satirise tyrants, but they don't themselves tyrannise over us. Novels, if they're doing it right, show us people as they are in their complexity, not as they should be. They can create disorder, using language to free us from the bondage of a particular way of seeing, increasing our autonomy. Disobedience, as every child knows, is a form of freedom, and absolute certainty is a form of madness. Mockery is authority's nightmare, and the return of religion, of the tyrant and strong man, should inspire us to better doubts and more questions, naivety and enquiry. Tyrants seek to heal conflicts by

pretending that everything is already decided. They need to be reminded that questions about power, gender, class and sexuality can never be defined once and for all, but are conditional and must be open to experimentation. This is radicalism, which bears no resemblance to the phoney conservative 'radicalism' we've been subjected to.

Notions of criticism, free-ranging thought and questioning are universal values which benefit the relatively powerless in particular. If, for a moment, we gave way on any of these, we'd leave ourselves without a culture, and with no hope.

Fanatics, Fundamentalists and Fascists

In the early 1990s, after the shock of the 1989 fatwa against Salman Rushdie, I began to do some research among those who condemned him, and learned that a strange thing was happening among young British Muslim men and women. I first wrote about this strange thing in my novel *The Black Album*, which concerns a young man who comes to London from the provinces to study and finds himself caught between the sex-and-ecstasy stimulated hedonism of the late eighties and the nascent fundamentalist movement. At the end of the novel the Asian kids – as they were called then – burn *The Satanic Verses* and attack a bookshop.

I followed this up with a story called 'My Son the Fanatic', which was published in the *New Yorker*. Set in Halifax, this story became a film made by the BBC and was released in 1997. Once more it was centred around a strange thing I had noticed: that these young Muslims wanted less sex, more obedience, world-wide revolutionary change and their own state based on religious principles.

I can't say it seemed crazy that young people were turning to utopianism and revolution. After all, many of

my generation had been Maoists, Marxists, communists, militant feminists, supporters of black power and Trots of various kinds. Some of these former 'revolutionaries' now owned several properties and were retiring with good pensions after a lifetime of service to journalism, academia or the arts.

However, the return to a new submission, this time to Allah, along with belief, sincerity and puritanical sacrifice, was shocking because I was aware that immigrants like my father had come to Britain not to foment political change or make Britain more like anywhere else. After the horrors of Partition and starvation in India, they wanted safety, security and education for their children. The mother country might be the seat of Satan, with an absurd idea of itself as racially superior, but it was more tolerant than most other places, retaining, so the older generation believed, a patrician, Orwellian decency and a spreading liberalism which would benefit the new migrants and their children.

Yet it didn't; the humiliation and infantilisation of colonialism and racism remained. The whites, to misquote Enoch Powell, had always had the whiphand over the coloureds. There was still a deep bitterness and resentment in the community. And so, in 'My Son the Fanatic', the young man begins to throw out his pop paraphernalia and what he considers other trivial possessions. He leaves his white fiancée and rejects the fanatics of

neo-liberalism and the Thatcherite worship of the market, which promised somehow to elevate extreme selfishness to a liberatory creed. Accusing his father of being 'too Western', the son becomes devout and imports an extreme preacher from Pakistan to instruct other local kids who feel the same way.

It was becoming clear that some young Muslims had had it with their parents' compliant and sycophantic attitude towards their white masters. They no longer wanted to be failed whites. The father's path was a lost highway. Now they had discovered an ideology which provided purpose. The old religion could be used for new things.

We know now that the fatwa was a foolish if not fatal misstep for Muslims. It was where this community, formally known as 'Asian', began to advertise itself as censoring, small-minded, regressive and ashamed of its more intelligent, critical and creative members. But it worked as a challenge to the West, and it was just the start.

Since I wrote those fictions in the mid-1990s – and after the attacks on the World Trade Center, wars in Iraq and Afghanistan, along with reprisal bombings in Europe and other horrors – the Western world has lurched to the right, partly by constructing Islam as an alien Other. Now, after Trump, Orbán and Salvini, Muslims, like Jews or Negroes in other contexts, will be punished, stigmatised, harassed and surveilled. We are all afraid – and with good reason.

Muslims didn't help themselves. But at least they, unlike many in the West, recognised that war and violence would always go both ways. How could it be strange that there would be bombings in the West while there were bombings in the East?

Now Muslims have also become the victims of a confining caricature which has helped build the new Right. Race and religion will take a central place in the creation of a new Europe, and the Right will use Islam and Muslims to create totalitarianism. Not that minorities haven't been exploited before in this way. It should be noted, nonetheless, how much the two sides resemble one another. The contemporary view of Muslims is the mirror image of the current far-right ideology overtaking the West: sexist, homophobic, insular, monocultural, combative.

The form of political Islam I wrote about – emerging in the West in the 1990s – is exhausted as a future. Clearly it led nowhere except to nihilism. It was shameful that the formerly colonised could barely wait to re-colonise themselves within a prison of religion and ideological darkness which, in the long run, made them subject to a double dumbing down and oppression: of censorship and intellectual stagnation. The submission they so desired – to be God's instrument – is a static, slave-like ideal which freezes everyone.

Fortunately there is a fresh generation of young Muslims who can create a new radicalism, which is

neither religious nor populist. They can rise against the power of a rigid, prescriptive Islam, and make a new identity in the face of the new fascism and the seductions of hate. This means the young must first take on their elders and a calcified ideology.

There's nothing that suits the white ruling class more than benighted, uneducated lovers of God. If multiculturalism has become a diversion, monoculturalism is worse. What really scares contemporary power is not Islamism but solidarity: the idea that the marginalised could forge an alliance with the other disaffected young of the West to combat the obscene resurgence of racist enjoyment which is so stimulating our politicians at the moment.

The formerly excluded and deterritorialised could become an organised class of enlightened, educated young people prepared to join with others across Europe to struggle for freedom, equality and social change. This fight for a new identity not based on hatred and exclusivity, and supported by shared secular ideals, is essential and necessary. A new radicalism would give us something to look forward to in this fateful era of mob rule.

Nowhere

Call me Ezra. Call me Michael or Thomas. Call me Abu, Dedan, Ahmed. Call me Er, Asha, Trash or Shit. Call me whatever or no one or nothing. You already have more than enough names for me.

In this place my identity and even my nature changes from day to day. It is an effort for me to remember who I am. Like a child rehearsing his alphabet, when I wake up I have to reacquaint myself with my history. That is because I am not recognised. I have no reflection here. Except in her eyes. When Haaji sees me I come to life, if life is the accurate word, which it probably isn't.

Wearing my only shirt, in the small shabby hotel room which we are forced to leave, I jerk about on my toes waiting for her. I see that I am very thin now: near-death has something to be said for it. It is a very odd thing, living every day in fear. At least you get to practise renunciation, but I am, I have to say, a reluctant ascetic. At home I never went to bed with less than five pillows.

My few pathetic possessions, along with my sacred books – Hegel, Dostoevsky, Kafka, Kierkegaard – are in canvas bags. I hope they send a limousine because I am

not sure how much further I can walk. Something tragic has happened to my nervous system which makes me twitchy. My head is too heavy and my body scarcely obedient. I'd have been better off as a cat.

She was lucky to find a job as a maid here. For two weeks she has been hiding me in her tiny room. We took turns to sleep on the plank of a bed until I made an unavoidable mistake. I had a terrible dream, screamed, and was discovered. Here, even your nightmares can betray you. In future – and I also use this word with a laugh – I will sleep with tape over my mouth.

She and I must get out again. Who knows where. They suggested I am some kind of security risk, or terrorist, and that it would be no trouble to them to report me to the police, who will interrogate me again. She begged them not to bother since I have no religion and, I have to admit, no acknowledged beliefs. I am only a harmless bookworm as soft in the head as ice cream. No terrorist ever found inspiration in Kafka. And I'm far too lazy to start killing people. I don't give a damn for invasions or wars; I expect nothing less of humanity. But all this, what has happened, is an inconvenience too far.

In my city far away I ran a coffee shop.

She is angry. She has had enough. And she is all I have. I like to believe she would never abandon me. She must know I will not survive. This strange life is too much for me and my mind is a madhouse. In two minutes

everything could become different. I will know from her face.

Haaji is ten years younger than I am and not as dark. As soon as she arrived she stopped covering her modern hair. She is not regarded with the suspicion us men are. She could pass as a 'normal' person. I'd never touched a body so white.

For a few weeks I became her savant. She had never met anyone like me, and my view of the world became hers. She risked her life to protect me, though I am not sure if she will continue to do so. We will see what I am for her.

My little city in my country was destroyed. I fled and travelled here to the land where the Enlightenment originated, to the democracy where I became a nigger overnight. I woke up to find I'd turned into someone else.

The foreigner has been suspect from the beginning of time. But let us not forget: we are all potential foreigners. One day you too could be turned over from the white side of life to the black. It takes a moment. Others will notice you do not belong; you will disgust them; they will fear you.

My close pal from the coffee shop, One-Arm, was organised. I'm aware this is unusual in a poet. We escaped our country together and the first few weeks were chaotic and rough. But he had connections here. He guided me.

With him, when I arrived, I got a job, as did many

others, working for Bain, the man who secures empty houses and apartments in the great city. And so, after the terrible journey, things began to look up for me. I was even excited to see Europe again, the buildings, libraries and landscapes, though last time, when I was a student, I had with me a tourist guide, a camera and a cheerful curiosity. This new perspective – think of a man viewing the world from inside a litter bin – is, let us say, less exotic. It is more informative to be at the mercy of others.

After we arrived in the new city, as we waited to see how things were going to go for us in the West, we began to work for Bain, the king of miles of wedding-cake mansions and magazine apartments. We swarm of new nomads, walking in history whether we like it or not, are the new slaves. We wanted jobs rather than to sit it out in transit centres for years.

Bain could do anything he liked to us. We were compelled to obey and even admire him, which he seemed to enjoy. We shadow people have no tourist guides or even meaning. Strike us if you want to. Take advantage. No one complains.

We were inside the most beautiful houses and apartments in the world, places I'd never seen except on television, and certainly never set foot in before. We could enjoy these properties, empty of life and people, more than their owners did. Those bankers, money launderers,

princes and dirty politicians, living in Beijing, Dubai, Moscow or New York, might have forgotten about them altogether.

I can tell you: emptiness doesn't come cheap. I'd never seen so much light in a building before.

Things that were not dirty, that had never been used, had to be maintained. That was our job: cleaning the clean. Working all day every day, we cared for deserted swimming pools, plump new beds, steam rooms, saunas. Acres of wooden floors and yards of blinds, walls, garages and gardens had to be attended to. The repainting was continuous. People get less attention, but they are worth less.

Our team went from house to house. Sometimes the places were close together, in the same block. Other times we were driven around in a van. People like me, we so-called talkers and intellectuals, those of us who live by abstract things like ideas, words and beauty, are of not much use in the world. I wondered how long I could last in this job. However, in one remarkable house I was assigned to the garden, clearing leaves, pruning, digging.

It was in this house, under an elegant staircase, almost resembling the one in my favourite movie – and Hitchcock's best – *Notorious,* that I discovered a small room with sloping walls containing an old armchair. I guessed the billionaire owner had not only never used this space or seen the armchair; he didn't know it existed. What would he care that when I sat in it, and rigged up

a light, I was comfortable at his expense? Perhaps he was kind and would have been happy for me. Why not?

Just two months before this, when the shelling started in our city and we finally recognised the truth – that our lives as we'd known them were finished for ever – we had to clear out. I gathered clothes and as much money as I could get hold of. Then I stood and stared into nothingness: even while my companions waited for me, something kept me back.

My books. You might find this odd, but they were my main concern even then. There's nothing like displacement to give you time to read. Kafka, Beckett, Hegel, Nietzsche, Montaigne. My father had passed them on to me. They were my mind and treasure, my single resource.

When it was time to flee, and everything was falling down, I rushed to the back of my store, which also functioned as a library and bookshop, pulling down whatever I could carry, filling my hold-all, other bags and my pockets.

In the new city Haaji and I found ourselves working in the same house. Bain mostly employed women but he needed men for some work. At first I barely noticed her. She seemed quiet and humble, with her head bowed, wisely keeping out of trouble. None of us spoke much. This assembly of ghosts was in shock. Our mouths were shut.

When I saw her looking at me, I wondered whether she had seen me talking to myself.

Late one evening, when we had finished work, there

was a rap on my cupboard door. I was inside reading. At this noise in my secret place I was terrified. Was I about to be punished and dismissed?

Hearing her soft but urgent voice – 'Asha, Asha, it's Haaji' – I opened the door. She stepped past me and sat on a stool, opposite my chair. Her intrusion seemed brave. I was puzzled. I waited for her to speak.

'What's in that book?' she said at last. She pointed. 'And in that one? And that one?'

'What do you think? Why do you ask?'

She was able to admit that she wanted to talk to me, this small girl in her white work coat and white shoes. Two scared people sitting together in a cupboard. She asked me to say something about what I was reading. Would I explain it? I could tell she was clever and even educated, but only up to a certain level. Perhaps she'd had problems at school or with her family. She was thin and frail, yet with some determination to her.

This took place over many nights. I saw that I had to clarify and simplify my thoughts. There's only so much most people would want to know about Hegel. But she was fascinated to hear about the master–slave relationship, the interdependence of the owner and the servant, leader and follower, creditor and debtor. How they are bound together. The eternal impossible reflection.

I was surprised; I became enthusiastic. I wanted her to know what I saw in this stuff, why I said it was more

important than money. More important than most things
people valued.

'You're so kind, you can be my teacher,' she said.

I enjoyed that. It was invigorating to be of use again at
last. What did we need? Better words. Fresher ideas for her
circumstances. The new vocabulary gave her an enhanced
angle. She could see more clearly from the adjusted posi-
tion. What you think you're doing under the official
description you're not doing under another. Like sinning,
for instance. Suddenly it can appear under love.

What a discovery. Modesty has its limits. Let me say
that at this time, with her, I found myself liking myself
very much. I had a function. She made me into a person.

Like me, like all of us here, she was afraid and run-
ning from something. But unlike me, she was running
towards something. A new life; hope; the future. It was
good to see.

Haaji and I, as new companions, could consider our-
selves privileged as we went from house to house carry-
ing cleaning equipment. We got to see good furniture,
art, sculpture. Only the richest people could afford
Warhol's, usually the Mao. There were eerie deserted
swimming pools and kitchens with no food in them
bigger than apartments. We washed down sheer walls
of glass overlooking the city.

At night, when I was sometimes the watchman in these
houses and all was quiet as a monastery, the beautiful

quiet of a city, we sat with our feet up, compelled by the ever-changing night landscapes. In our way we could share the privilege. We could walk on the most luxurious carpets and eat on tables made of Carrara marble. We slipped into their swimming pools and floated on our backs in our pants. What a wrongdoing it was. How we violated them, living their dream. And how childish it made us.

In this panopticon, permanently under the unfeeling eye of some nebulous authority, Haaji and I did a dangerous thing. Our eyes lit up when we saw one another. Something was starting between us; luckily it wasn't what you think.

We began to play games. We knew where the cameras were. No one looked; Bain and his men rarely glanced at them. There was nothing to see. I'm not sure if any of us stole anything. We were searched all the time.

In my city I ran a coffee shop.

Haaji and I liked to pretend we actually owned these houses of the rich where we served. During these games we could be wealthy and royal. We strode about with authority, shouting orders. We discussed how difficult the builders were and how severely our lawyers would treat them. We wondered about lunches and lovers. I asked her which suit she preferred me in, and which tie and shoes looked best. We speculated about whether we would go to Venice or Nice for our holidays, if we would have sea bass or veal, champagne or vodka.

It was an empty exhilaration. One-Arm came to me with a warning. We had to be more secretive. The others had noticed. There were several black men working with us, mostly doing building work and deliveries. They were dirty, licentious, argumentative, threatening. Their language was incomprehensible and none of them had read a book. Forgive me, please. I hear you. But to each his own foreigner. Can't I hate arbitrarily too? Is that another privilege I have to forsake? Sometimes hating tastes better than eating.

One-Arm said the blacks were gossiping about us and they liked the girl. Why would these others want us to be happy when they were not?

In our closet, bent under the sloping walls, among vacuum cleaners, brooms, mops and buckets, Haaji and I talked harder by candle-light. Democracy, love, dreams, gender, virtue, childhood, racism: we had it all out. The sensation of infinity and no one else in the world.

She tried to show me her body, a madness I couldn't sanction. I looked away and told her about my coffee shop. To keep the café alive I'd describe the families, smiles and jokes of my friends there, now scattered who knows where.

In my city I ran a coffee shop. These beautiful words I recite each morning, like a prayer or affirmation.

I consider myself middle-class. With a hesitating, timid manner, I've always feared mirrors. I was never

much to look at, with bald patches, a heavy, duck-like walk and shortness of breath. I have had two lovers, but I was always scared of women and never keen to copulate. What is a man before a woman who is having an orgasm? Is there anything more terrible? I don't believe most people really like sex. Certainly, I found so-called sex physically intrusive, if not obscene. It seemed unbelievable that people could want to put their tongues in one another's mouths. Now, I loved motorbikes. A Ducati is a thing of glorious beauty.

Socrates said, I can only think of Eros. I take this to mean: how does one relate passion to the rest of one's life? Some people look for God, but I look for my own god of Eros in everything, and not only bodies. I see it in coffee and sentences. So I go along with St Augustine: I may have remembered it wrongly, but I like to think he said that having a penis was God's hilarious punishment for being a man. Your dick goes up and down randomly, particularly when you're young, and you can't control it by willing. In church, I found, it went up with inconvenient regularity. Then, when you're finally in bed with Cindy Crawford and she is murmuring your name, you know you're not going to make it. Forget penis envy, I'm all for castration. That is why I hide my penis in books. I'd rather read about it than live it.

There, before, in my city, with my routine, I was dedicated to my work and liked to serve. It was an honour;

I was proud of the little place. Making an Americano, offering pastries and newspapers, talking to my customers, seeing if I could charm them, this was my vocation.

My big motorcycle was outside, where I could appreciate it as I wiped the tables down and swept the floor. There were pictures and photographs on the walls – works I bought from local artists to encourage them. In the back of the café were books on architecture and comfortable chairs. My clientele were fine dissenters a blink away from prison: human-rights lawyers, academics, blasphemous writers, singers, anarchists, trouble-makers. I made sure to know them all by name. Sometimes I was invited to their houses. I imagined a band of aliens, bohemians and originals. Like Paris after 1946: Richard Wright and Gertrude Stein chatting.

Now, suppose some dictator takes the guns the West sold him and blows up your coffee shop. Not only that. The street, in fact the whole quarter, everything and everyone there, is, one day, obliterated in a surging fire. Suppose you look out at your neighbourhood one morning and everything you know is gone. Behind the smoke-storm there is only filth, ruin, smoke. The people you saw every day – shopkeepers, neighbours, children – are dead, injured or running. And no one recalls why making this hell was necessary or what good cause it served.

Civilisation is a veneer. Underneath we are incontinent beasts. Who doesn't know this? Yet it is not true.

If we are savages, it is because we are commanded to be so. Because we are followers. Because we are obedient.

People: I am coming at you with my strange ways. Like many others, I scrabbled to the city of the Enlightenment. I slept on benches and beneath dustbins. I shat in your parks and wiped my arse on your leaves. It was dangerous. Strangers roughed me up. I took that as an affront, having never seen victimisation as a natural part of my condition.

My papers were stolen as I slept. Later, I got new papers. I was forced to go to Bain. You should have seen the approval on his face. He had predicted I would have to ask him humbly for help. He had done it a hundred times with others and made sure it cost me. His friends grabbed all the money I had brought with me, and Bain took his cut. Then I worked to pay him back. I would never pay him back. Like the others, in exchange for some safety, I was the devil's for ever.

You must think me careless. I got new papers. Then I lost them. Really, it was then that I lost everything. This is how.

You walk along a quiet street in a normal city with your friend, One-Arm the poet. It is a part of the city which considers itself civilised. You see a woman in a café reading a book. Attractive people talk of Michelangelo. You see galleries and museums with people strolling and looking. There are new buildings with fabulous curves.

You want to go in. You tell One-Arm that even Ulysses went home.

You approach a bar. For you, the ordinary citizen, it is nothing but a bar. But to me, for whom the normal was a long time ago, it is a danger point. From where I see things, you might call 'the normal' a façade or window-dressing, just as the dying might think the healthy inhabit a stupid illusion.

Outside the bar a man is drinking. He looks up and his eyes take you in. Here, in the heart of paradise, an explosion takes place inside him. Your being outrages him. At the same time he is filled with a peculiar pleasure: this is satisfaction anticipated. I should say: madness is the mainstream now. Haaji calls it the new normal. For thirty years I was a free man. Now I am a dangerous dog in someone's path.

You grab your poeticising friend by his one good arm and you shuffle away. You have recognised definite danger.

As you feared, the man comes, with others. They are always nearby and they are quick. These are productive times for vigilantes, the protectors of decency.

Nihilism doesn't dress well. You wouldn't want to discuss poetry with them. They have shaved heads. They wear leather and have tattoos. They have clubs and knuckle-dusters.

One look at us is all it takes for them to know civilisation

is at stake. We raggeds with our awful belongings and need are a threat to their security and stability.

I have no doubt: it is dangerous for us here in Europe. I am paranoid, I know that. I hear interrogations and arguments in my head. I expect people to have a low opinion of me. We are already humiliated. Not that there isn't much for us to be paranoid about. If we are on the street, just walking, they stare and often they turn their backs. They spit. They want us to know we are peculiar to them, unwanted. They talk about choice and individuality, but it amazes me how conformist and homogenous everyone is.

We, the reduced, the primitives, savages and filthy drifting blacks, are terrorised. We, I say. We are not even a we. We are still a 'them'. The cause of all their problems. Everything bad stems from us. I needn't enumerate their accusations. I don't have much time.

We flee, One-Arm and I. We run as we've never run before. A blur of limbs, a streak of terror.

They catch us. They beat me so badly I can't open my eyes. I can barely hear. The police are indifferent, of course. The fewer of us, the better.

One-Arm was murdered that night, but people came before I died. Haaji persuaded Bain to let me stay while she wrapped me in her pale love. What use was a wrecked man to him? She convinced him I would soon be back on my feet. I wonder how she really persuaded him, particularly after he said he would have her skin made

into a pretty handbag for one of his employers. It wasn't entirely a joke. He was selling the women in other ways. Our bodies have their uses.

There were shouts. Haaji had been out looking for me, and at last she found me. My mouth open on the bed, the howling mouth, crying. Pessoa describes somewhere falling through space into a void, a vortex, a maelstrom. You see, he knows me.

Haaji must have been in love, or at least devoted at that time, because her kindness was unlimited. This will surprise you, but she had been uplifted by my optimism. These are dark days in a dark world for us dark people. And perhaps I'm some kind of holy fool. Yet I never stopped telling her that I believe in the possibility of collaboration and exchange. People can, I maintain even now, do creative things together. I'd seen it in the coffee shop, where good things were said. If there were only destruction, there'd be no life at all on this planet. Hear me: let us try some equality. Equality is such an interesting idea. Why is it the most difficult thing?

After the attack nothing was right with me. Bain had his group, and he had seen that Haaji was susceptible. There are many men keen to run cults, and many devotees who will join them if they believe they will be eventually rewarded. The cult generally, whether religious or political, patriarchal or matriarchal, has not stopped being the modern form of belonging.

There were those who saw him as a liberator. He was Schindler, protecting and hiding those of us threatened with extinction. Unfortunately he had his theories and preferred belching words to listening. I can see him pacing up and down like an imam or preacher, on a priceless wooden floor, while we slumbered at his feet.

Humour is usually humiliating and tyrants don't encourage such instant deconstructions. My mumbled quip about the price of disenfranchisement being the necessity of enduring hurricanes of hot air didn't boost my attractiveness. Unluckily for me, I'm an enthusiast and sceptic rather than a follower. In a properly efficient tyranny – the only ones worth considering – someone like me doesn't last five minutes.

Despite my desire to remain cheerful, if not cynical, the world was making me bitter. If you think literature is weird, try reality. I had always been an admirer of Beckett. As I giggled through his prose in my coffee shop and wrote his quotes on postcards to send to friends, it never occurred to me that I'd be buried up to my neck in manure. Unfortunately, the fictionists I admire give no instructions and require no sacrifices. That is their virtue and failure.

With nothing to lose, I had a good idea.

Since the attack, toothache had taken me over. My teeth were giving me unforgettable trouble. How could someone like me afford a doctor or dentist? The pain was too

much and I wanted to strike out at the world. Why can't people be nice? That's a good question, isn't it? Kindness has no politics and there wasn't enough of it in the world. I would introduce some. So I became keen to murder Bain.

He was rarely alone, but came out into the garden to smoke one night. He had his back to me: the part of him I most preferred. I was sitting behind a tree at twilight, reading by the light of a small torch. I noticed a branch nearby and it occurred to me to relieve Bain of his brains. I thought: aren't I really a murderer dreaming I'm a respectable man? By sparing the world an evil force I would receive both satisfaction and moral fulfilment. If you ask me, it is the sadists and perverts who cause trouble, being overly concerned with what others are doing. Didn't I want to be good?

He turned away.

I thought: I can still catch up with him, and strike him. There is time. Billions have murdered. Many liked it. Didn't they seem to live on, unworried, continuing to enjoy TV and discounts at their local supermarkets? But I was weak. We are all Hamlet's brothers, and killing wasn't a breeze for me. Why should it be? I let the moment go. As he disappeared along a path, I picked up the branch and knocked it in regret against my knee. The log disintegrated.

* * *

I wasn't able to do the work Bain demanded. I was limping and weak. I had no rights and no money. There were rumours he was selling the organs of recalcitrant workers. Not that he would get much for mine. I asked Haaji to leave with me.

It was touch and go. I had to tell her that the protection she sought was an illusion. There's never any shortage of tyrants and their self-interest was catastrophic. She had found the wrong master in Bain, and I couldn't be a master at all.

We escaped at night, taking back ways and hiding in forests, washing in petrol stations.

We were settled in a small town which is worse for us than the city. The residents are restive and nervous. There have been bombings and attacks throughout the country by maniacs, religionists and politicos. There was a shooting not far from here. The politicians hurry down like housewives at a sale. After each tragedy, the people hold vigils and light their candles. They link hands, weep and swear they will never forget. But they do forget when there is another and then another incident.

They insist that they are being forced to put their values of decency and tolerance aside. They must protect themselves against outsiders. We are not the saints they thought our suffering obliged us to be. We have let them down with our banal humanity.

And here we are now. Haaji got a job in the hotel and smuggled me into her room. We didn't talk. I had no mystery left. I'd taught her everything I knew and it wasn't enough. After a time I saw what was wrong: I didn't know what to ask of her.

I lay there for days. The room became a kind of tomb. It was a good opportunity for me to think about death. Socrates, after all, wanted to die in his own way, when he was ready. It was not suicide; death was not a 'must-have' for him. Nor was it despair. Rather, it is a question of whether there is any profit in living. People want to live too long now. Considering my own death certainly changed a lot in me. I lost a lot of fear.

Late at night, if the coast was clear, she and I would sometimes sneak out together, through the back door. She walked ahead, wearing lipstick. I had to go behind, tattered, making sure not to lose sight of her. Our distance was essential. A woman like her, with a man of my colour, we could never hold hands. They already believe we copulate more than anyone deserves.

At the harbour we'd sit apart, on different benches, joined by our eyes, signalling to one another. I have come to like, if not admire, ordinariness. Along with an empty head, it is the loveliest privilege.

One night, when the weather was wild and the sea a frothy cauldron, I caught sight of many other boats on the horizon, bringing hundreds more of us aliens

with upraised hands, shouting 'Freedom, freedom!' Meanwhile there was a hubbub in the harbour. Some wanted to watch them drown. For others, human values had to persist. While they fought among themselves some of the boats went down.

* * *

Now I hear a noise. It is her footsteps. She comes in. She barely looks at me. She is different.

She gathers her things and walks out into the street. She is ahead of me as always. She knows how weak I am, but she is walking fast, too fast for me to follow. She knows where she wants to go. It is raining. I hurry along. But it is hopeless.

I call after her. I want a last glimpse and a memory. 'Here, take them. You will need them.'

She stops.

One day everything will be borne away in a great fire, all the evil and all the good, and the political organisations and the culture and the churches. In the meantime there is this.

I hand her my bag of books. They are inside me now. Let it go.

My Beautiful Box Set Binge

If you really want to know about it, I will own up. I've barely left the house in the last eighteen months because I've been watching what for me seems like a lot of TV, around five hours a night. And I can't say that a moment of it – apart from, say, the second season of *Mr Robot* – feels like wasted time. There are scenes in *Mad Men* and *Transparent* which are as accomplished, profound and truthful as anything I've seen in the cinema. And the episode in *Breaking Bad* where the former chemistry teacher Walter White buries the money he has accumulated by selling crystal meth – transforming the spoils into waste or shit – is one of the most illuminating in all art.

Apart from the news, sport and documentaries about the Beatles, I hadn't watched much television since the 1980s. Nor, as a young man, did I consider writing for TV. It was too compromised; and, with a few exceptions, the overall standard was low. As for the movies, many of the film directors writers worked with wanted to be artists rather than story-tellers, a vanity which ruined many directors and displaced writers. The screenwriter's best hope was to resemble a back-seat driver, yelling mostly unheard ideas

from behind. It looked like the truest test of the good dramatic writer was his or her ability to write plays.

This was before – before I discovered that far from alienating either viewer or writer, television was *the* great social integrator. Everyone was watching it. I could talk about it with my mother, my teenage kids and their mates. Visiting friends in whichever country, I learned that, like a secret passion, everyone had their favourite shows, had strong opinions about them and couldn't wait to hand you your coat so they could continue with series six of *The Good Wife*. Before you left, they would, however, probe you for your favourites, for something decent that they might be in danger of missing. It could easily provide the most passionate exchange you'd hear all day. You can imagine, now, someone watching television shows for the sole purpose of having something to say at dinner.

When I was fifteen, a kindly editor at a notable publishing house, finding a novel I wrote promising, would visit me in the suburbs on Sundays to teach me to write. What he emphasised was character. Using an idea derived from E. M. Forster, he taught that writers should make the individuals they created 'round' rather than 'flat'. You'd accomplish that by the addition of details, often contradictory, because that is the way people are, and soon you'd see right through them to their skeleton and they'd move around almost of their own accord.

The television show is ideal for the exploration of character under pressure because of its duration. I recently watched all eighty-six episodes of *The Sopranos*, followed by all of *Breaking Bad*; then I did *Gomorrah*. I would happily have watched more. The slowness of *Mad Men* – interestingly, a show derived from literary origins: you cannot help noticing in it the shadows of Fitzgerald, Cheever, Yates and Updike – disoriented and irritated me until I adjusted to its rhythm. You get to see the characters in bed, in the kitchen and at work; you understand how politics and gender division produce them, and, uncannily, how little freedom they have. Length makes for complexity. Seeing Tony Soprano in and out of the toilet with an upset stomach, or taking his beloved daughter to university before murdering an acquaintance with his bare hands, is not something there'd be space for in *The Godfather*.

I grasped how far television had advanced, that it had replaced pop as the major creative form, when I noticed that the best writers – from David Chase and Matthew Weiner to Jill Soloway – recognised it as an event. They had long given up on the idea of showing that crime doesn't pay. They had also kicked out the soft idea that audiences like sympathetic protagonists. Television writers saw that the audience loved to see deceit, manipulation and evil: people doing what they wished they could do, had they been blessed with the

balls, greed or stupidity. (Remember, Hitchcock said, 'The more successful the villain, the more successful the movie.') And the new television added an extra, brilliant thing: it kicked out the happy, redemptive ending for ever.

The long-form show is perfect for examining cut-throat capitalism because all these shows are concerned with the amassing of money, which has now come to justify any malfeasance. The only attempt at virtue is the idea that the purpose of the money is to provide security for one's family. (Never mind other people's families.) This degree-zero nihilism is central to the beautiful, sadomasochistic horror of *Gomorrah,* for instance.

The quality of imagination in any society is directly related to opportunity, to the amount of space it can find, and whether there is belief in the possibility of dreaming, risk and experiment. While the works I've discussed are often about the terrible mystery of human destructiveness – as well as about the replacement of humane values with materialistic ones – their existence is a tribute to the writer's signature.

As importantly, they are also a compliment to the erotics of collaboration, an appreciation of the work people can do when their imaginations run together. Such television shows employ numerous directors, producers and actors. They are an opportunity for writers – who are

being manufactured in creative writing courses, in their dozens – to make a living in popular forms.

The best art – Hitchcock, the Beatles, Picasso, Miles Davis – combines experiment with popularity, taking the audience from somewhere familiar to somewhere new, exploring the not-yet-said.

Now I am afraid I have to go. I woke up worrying about Don Draper, and I am more than keen to be back in the office with him.

An Ice Cream with Isabella

'You can't have everything,' my mother used to say. But you can – I learned for myself – have something. And that something can sometimes be something else.

In the evening, when, like the rest of the population, Isabella and I settle down to watch TV – we are always keen to enjoy a sadistic and lengthy show in our pyjamas – she and I like to share an ice cream. It will be soya, as it happens, because of my diet. It will be covered in thin chocolate. It will be delicious.

Deputed to fetch it, Isabella soon lies back behind me, and I hear a snappy unwrapping, followed by a pause. I hear breath as a tongue extends. There is a lick followed by an exploratory nibble and, very soon, a strong if not urgent bite into the expanse of thin chocolate dusted with frost.

This is it: she has begun on the ice cream, right next to my good ear. I am agitated and excited. I begin to feel greedy. She bites again, hard this time, and sighs.

What an enticing sigh. But I must wait. Eventually, of course, she will hand the ice cream to me. She has never been unreliable, which is a relief. But I am an impatient

person, and not improving when it comes to bearing frustration. I can convince myself that my fierce excess of appetite will be too much for me. I could believe that she will forget me now, or that I have temporarily become nothing to her, as I hear a series of little detonations in my ear. What is it?

She is sucking on the ice cream. She is taking her pleasure without me.

I don't go to many dinners or parties and have little desire to explore the world. Happily narrower, I don't want to know; it seems unimportant now. This is partly out of aged indolence, but mainly because everything I need is here.

So: how delicious it will be, that soya ice cream, when I have waited, when it is my turn. It is all I want.

In the mornings I think about the Beatles. I do it most days. It is a lifetime's work. How they worked together, along with George Martin and Brian Epstein, to become the perfect, more-or-less leaderless example of a collaborating unit. Those brilliant young men, hooked up to one another, doing something together they could never do apart. A constellation of characters, you could call it, or a working circle. People with technical minds use the words 'horizontal unit'. You could add: it would have been a necessary but terrible – and sometimes unbearable – dependence.

I could, of course, go solo and have my own ice cream, as the Beatles eventually did. There are more ice creams

in the fridge and many more in the world, and I could scoff as many as I like alone and out of sight. However, you could make a phrase of it and say: it doesn't matter what you're doing, as long as you are doing it with someone else. You can't make yourself laugh, after all. Or pat yourself on the back. Eating an ice cream alone could be a lovely liberation or it could seem like a dismal thing.

Since I am known to be dangerous with ice creams, Isabella will, as a precaution, have already brought me a paper napkin and jammed it under my chins so that when my turn finally comes I will not smear up the sofa or my clothes. As the chocolate begins to flake, I will be able to pick up the crumbs from the napkin and lay them on my tongue to melt.

She is still nibbling. How can she do that, when she knows I have always been anxious about food: whether it will ever arrive and if there will be enough, or if I will be left wanting more? I was brought up in the 1950s, after all; not a great decade for food. This could become tense.

As children ice cream was our favourite treat, and on Saturdays our parents would take us to the newly opened and very modern Wimpy Bar on Bromley High Street. Our second treat was to wait in our living room for the new Beatles record to be played on the radio. It still makes me sad to know I'll never hear a new Beatles record for the first time again. The Beatles, whom we worshipped, gave up one another and the supernatural thing only

they could do together for other lovers. They must have become claustrophobic in that cocoon and wondered if they were as talented as people made out, or if it was really down to the other guys, the friends waiting in the studio who could mock or improve you. It was time for monologues rather than conversation. And, after a time, faithful to themselves, they found other partners.

Isabella passes the ice cream to me, and, having enjoyed it, I pass it back, but she says I can finish it. At last I wipe my mouth and settle back with my eyes closed, like the sated infant I want to be, in this burrow of love. Soon we will be asleep.

Sometimes, as Wallace Stevens wrote, the world is ugly and the people are sad. It's not always easy to enjoy. After many years of idiocy and waste – and several crooked diversions – sharing an ice cream with Isabella is enough to convince me that everything I have ever wanted and needed has culminated in this moment, where there are no fears or terrors.

Tomorrow I will listen to the Beatles again. Tomorrow there will be more talk with Isabella; more licking, biting and ice cream. If I am lucky, there will be more the day after that.

Eating an ice cream: a simple thing which has turned into a beautiful collaboration. It is everything I have ever hoped for or wanted.

The Billionaire Comes to Supper

It wasn't until they had to paint the living room wall that they realised the Billionaire was a billionaire.

Both Luna and Shiv had been leaning their bicycles against the wall, and when the flat's owner, a good friend, informed them he was coming back to repossess the place at the end of the month, they thought it would be courteous to repaint the scuffed surface before they left.

Shiv used the living room to teach, and the painting work was not finished when the Billionaire arrived for his lesson. He was learning Led Zeppelin's 'When the Levee Breaks'. He looked at the empty white surface and said, 'I should get you something for that space.'

Pupils often brought wine, biscuits, oranges or flowers. But the next time the Billionaire came, his driver accompanied him into the flat with a large framed and excitingly dramatic photograph of Jimmy Page, signed by the photographer.

The Billionaire took it from the driver and handed it to Shiv. 'This is for your wall, with gratitude and apologies for all the bum notes you've had to endure.'

Shiv thanked him, leaned the photograph against the

wall and completed the lesson. When the Billionaire left, Shiv looked at the picture for a long time, shifting it here and there. He texted the Billionaire his amazement, saying it was the loveliest thing he had owned.

Luna taught piano in schools around the area; Shiv mostly taught in the large flat they'd had for a low rent the past year, owned by a guitarist who was on tour with a musical. Shiv had had good fortune in recruiting a significant number of private pupils from nearby. If the students were young, he went to their houses.

Several parents – bankers, surgeons and executives – had also asked for lessons; one of them had recommended him to the man who became known as the Billionaire. The Billionaire had grown up loving the blues and R 'n' B, and needed someone to help him improve. He had been Shiv's student for a couple of months, sometimes coming twice a week.

The flat had a garden which attracted birds, foxes, squirrels and local cats, and they liked to breakfast outside. It was situated in a wealthy area, where there was a park with a lake nearby and excellent transport. Shiv was impressed by size of the houses and the affluence of the families he visited, with their gardeners, cleaners, au pairs, other tutors and obligatory personal trainers.

Some of the parents of his pupils spoke to him abruptly if not dismissively, as if he were on a par with the 'staff'. This was disconcerting: not only was his father a solicitor

and his mother a doctor, he had always considered the devil's music he taught to be classless. He complained to Luna that soon he'd be asked to use the side entrance.

That night Luna came home and saw the new picture leaning against the white wall. She too was knocked out by the portrait of Jimmy Page in his rock 'n' roll glory. They opened a bottle of wine, sat in front of the picture and discussed whether they should display it on the freshly painted wall, or wait until they'd found a new flat. If we find anywhere, and if there's room for it, as Luna put it.

She stayed up late. Coming to bed, she woke Shiv to say she had incredible news. She'd researched the photograph and found that not only was it an original – which they'd realised – but signed it was worth at least £3,500. Maybe if they sold it, they could get more. Wasn't that an idea? Didn't they need the money?

Shiv wouldn't sell it; the Billionaire would notice. Not only that, this photograph would stir every student who came by. Anyway, he already adored it. He knew he'd miss it. It could be the start of a collection, a new hobby for them both, if they ever made any money.

And she had discovered something else important: he was a billionaire. Now in his mid-forties, he had invested in tech early on, bought property and restaurants, and was richer than many of the songwriters and singers they admired. What about that?

Shiv was surprised but also irritated. What about it

indeed? He was too lazy to research the people he taught; it was intrusive. If someone wanted to play 'Back Door Man' on the ukulele, what did it matter what their day job was? The fees remained the same.

But why? Luna asserted that people like them couldn't afford to miss an opportunity; it would be stupid to be 'left behind'. Shiv said he didn't see what the opportunity was. She replied that that was typical of him. How? he asked. How is that typical? And of what? But if he didn't get it already, she was too tired to explain.

The next time the Billionaire came for his lesson, Shiv noticed that Luna not only remained in the flat, she was listening if not watching from the kitchen. He caught her head bobbing in the mirror.

Never do that, Shiv told her later. It was distracting and he thought the Billionaire might have noticed. Do not spy. Your eyes looked mad. He'll think we're crazy and he won't come back. Hey, what is it?

Come here.

She was naked in a moment. They made love in front of the picture.

After, she remarked that the Billionaire wore no jewellery, his phone was old, his jeans and T-shirt ordinary. He might appear polite and modest, and always did his homework, but he was, apparently, notoriously tough and demanding. There had been complaints and law suits from staff. How brilliant and quite strange he must

be to have achieved so much. She had found out a whole lot about his family. It was like *Dynasty*, and . . .

Shiv put his hand out. Stop. Stop there. He didn't want to hear any more. It was pointless.

But, she continued, she'd noticed the way the Billionaire leaned forward and listened to Shiv, his music mentor, with curiosity and his full attention. He must admire Shiv: his hands, his voice, his calm. Maybe he even loved him. Perhaps he wanted to sleep with him. Are you sure you don't feel something for him? You can tell me. Don't be inhibited. Touch me, and let's explore it. Let's go there.

Perhaps you're interested, Luna. Yes? It is true, I do sometimes love my students, Shiv agreed. They move me. They want something from me, and I want to help them. It's an exchange, a kind of *agape*, or objective love. Not sexual at all. Not like that, no. It is a much deeper connection, that of people collaborating and sharing.

Whatever: Shiv had some kind of hold over him. It was there; it existed. That was something they could work with. There was demand and they were well positioned. Her best friend Winnie, a charity worker, already wanted to know if the Billionaire was interested in learning Pashto, the tango, embroidery or a new sexual position. If she and Shiv didn't push, others would be clamouring to get to him.

I'm sure, Shiv said. If this were a noir and we were lucky enough to be no good, Luna my love, we would

strangle and knife the Billionaire together, and enjoy our work. We'd wrap him in the rug, drag him out, shove him in the rubbish chute and buy champagne and a red car, and have sex. We'd steal his identity or change our names to Bonnie and Clyde. But that would in no way transfer his dough to us. We'd have lost a pupil. We are, unfortunately, in reality.

So true, she said. You've said it. What fucking shit reality is.

Envy is worse. It is a terrible thing.

It really isn't, she said. Not if you use it as a guide to what you want. A map of the future. A direction. A destination to aim at.

Winnie had asked: why help others to develop when you're going nowhere? Why do so much for them and nothing for yourselves?

Shiv, isn't that a good question?

They were relaxed, lying down and drinking in front of the photograph. If they turned it, they could see themselves reflected in the glass. They talked as they hadn't been able to since the miscarriage. For the last few months it was as if they'd been stunned and didn't know how to move forward. Or whether they wanted to.

They were frivolous. What a drag it must be, being so rich, with everyone wanting something from you, so that your friends all had to be loaded, until you were isolated with other billionaires. Of course, as isolations went, it

would suit her. A villa by the Mediterranean in Italy with sublime views, fine linen, old paintings, good tiles in the bathroom and a home cinema; a little boat, and no anxiety about whether they could meet their costs.

You are becoming very materialistic, he said.

Am I?

I had no idea. Is it the influence of Winnie? I like money, but not so much I'd work to get it. Apparently sex and money can make people mad, but I never imagined it of you, even after seven years together. You seem strange now. I look at you differently. You are unpeeling in front of me. I wonder what is really underneath?

I had no idea myself. Until recently.

Until he came? He's done, or undone, something in you. In us. We can't stop it now. What is it?

Not only him. Life itself. We are almost thirty and we have lost something. Answer this: are we going to be at this level for the rest of our lives? Are we? Is that how you see us?

No need to get sharp and cranky, he said. Let's face it, we are going to remain for ever at 'this level' unless one of us writes a hit record. We've tried for years. It's getting late for fame and fortune. Paul McCartney was my age when the Beatles broke up.

The argument continued the following day. He had begun to pack up their possessions and, after work, trudge around flats they might rent, showing her photographs of possible places.

Grim and grimmer, she said, refusing to look at them properly and even pushing his phone away. She would rather sleep on the street or die than live there, even if they did have a photograph of Jimmy Page to cover the mould.

We do actually have to go somewhere soon, he pointed out. We can't escape the fact that we must leave this area and may never have such a nice garden again. We'll have to travel on public transport to get back here. We'll lose pupils. They won't want to come to us for fear of their lives. But what can we do? We can only continue.

She was talking over him, of people they knew. One friend's father would sell a painting; another's aunt left them a house in Venice or the country; someone else sold a first novel to Hollywood. There were all kinds of stories. She wanted a *story*. Why the hell didn't they have a *fucking story*?

Shiv, open your eyes. Look around, baby. We can barely see the sky for the cranes above us. There are lush new apartments with nice balconies and forbidding high gates being built all around. Maybe they'll let us in to give a lesson, but we will never live there. Who are they for? Why not for ordinary educated people like us? We're losing our place. When you played guitar in a bar the other night, it was like they were going to ask you to serve drinks and wash up. I love you and hate to see you like that. But are we trash now?

Not quite. Patiently he said they had to recognise

that, despite their minor complaints, they were the luckiest couple alive: unlike most people they had work they loved, and while there were shortages, didn't they have enough of everything? There was always some-one who had more, so why ever think of that? Did she envy Bill Gates? Surely the Billionaire was frustrated too. Shiv knew he was. Money couldn't buy talent, and the Billionaire's wish was to stand on stage under the lights and play a solo like Jimmy Page. He would never do that.

Are you asleep? she asked. Hadn't he noticed anything about her – that she had started to hate her work; it would soon kill her spirit, doing the same thing every day with mediocre people they had to flatter. Why wouldn't he recognise her dissatisfaction? Her envy wasn't the prob-lem; *he* lacked ambition and hope, the engine that kept people's fire alive.

He took offence. What else could they do but live their lives?

What could they do? She had many ideas.

Like what?

Stop being so polite, respectable and restrained.

For what purpose?

First off, he could open up and discuss their situation with the Billionaire. If the Billionaire had made himself so rich, he could easily help make them just a little bit rich. He could make suggestions. He must be full of good ideas and imagination. Why shouldn't he help them?

That would be a start. They could take it from there. She would tell Shiv what to propose.

Shiv started to laugh; he couldn't stop himself. This infuriated her until she said, if you tell me one more time that we are happy because we love one another and we love our work, I will knock you down. Okay? It's complacency, and I want to change things now. I would sleep with him –

You would sleep with him?

Probably. Yes. Why not?

Why not?

Wouldn't you?

No.

You'd want to watch, though, wouldn't you? I knew it.

He shook his head, and she walked out. He couldn't find her for several hours and began to worry. He couldn't look for her because he had to teach.

As the Billionaire was packing up his guitar and preparing to leave, Luna suddenly skipped into the room in her best clothes, put her arms around the Billionaire, kissed him and thanked him for the photograph.

She'd had an idea. She wanted to ask him to supper, at the end of next week, with just a handful of close friends. Would he come? It would be simple but lovely. Please, would he come?

Yes. He would love to. That would be very nice indeed. That was very generous. So kind.

It was a frenzy then. They made a short list of friends to invite. The cast would be made up of two other couples and a single woman to make up the numbers. The first people they asked, a couple who might be impressed but not over-impressed, refused immediately. Billionaires were no longer fat men with big cigars, fine suits and arrogant swaggers, but that didn't prevent him being an exploitative bastard, even if he did work with wildlife.

Among the single women there was a rush. They could have sold tickets, filled a stadium and live-streamed it. But Luna insisted that everyone who came should be calm and classy; nothing slutty to embarrass them. In fact, she needed to know what everyone was wearing. In the end it had to be Winnie, who pushed, who then begged, until Shiv said they should relent.

The simple supper, which Luna was referring to as an 'investment', took three days to organise. They scoured cookbooks and markets, bought candles, napkins and good wine, borrowed plates and cutlery, and cleaned and polished; they discussed the music extensively. They were almost broken before it began, certainly financially. Shiv said the Last Supper must have been simpler.

* * *

The evening of the supper, the Billionaire, good-mannered as always, had brought flowers and pudding; the others

wine or ice cream. The table talk was light, about exhibitions, shows and plays.

Luna, observing him when she could, realised that the Billionaire hadn't really been silent, which would have drawn attention. What he had done was ask the others questions, keeping the conversation going. When he did speak, it was banal. Winnie had insisted on sitting next to him – Luna said not on top of him – and Luna had instructed her to ask if he thought someone would be interested in funding a school for teaching music. He didn't think it was a bad idea, but schools weren't his area. He had been a rebel, dropping out early.

One of the others, towards the drunker end of the evening, became bold and asked him if he knew of any killer investments, you know, at the bottom end, for poorer people. The Billionaire laughed; the wisest thing would be to keep your money in an ordinary bank. Never try anything exciting with money, he said. Just be cool and enjoy it.

As a surprise, he and Shiv announced they would play 'Going to California' on acoustic guitars. At the end, everyone applauded and asked for more.

The Billionaire apologised and left, saying he had to get up early the next day to go to Africa, where he was expanding his charity. He'd enjoyed the food and the company, and was delighted they liked the photograph so much.

They all crowded at the window to watch his black car slip out of their street.

How could he? Luna said, in front of everyone. I don't believe it. The wildlife will be eating caviar. He brought us cake! That was what he gave us, after all we've done for him.

Oh Luna, Shiv said, what gave you all that stupid hope, when nothing was ever really going to come of it all? He already has everything! He can afford to disappoint.

Shut up, she said. Please. Let's forget all this! Put on some music, I must take off these shoes! Everyone, we must dance and drink now! Shiv says we must live in the moment, and this is it!

Something did come of it. She collapsed and stayed in bed for three days with some kind of fever. Shiv was packing for them, but sometimes joined her. In bed, she began to use the Billionaire's name, and Shiv followed her. The Billionaire became an obscene stimulant. For a while he was there with them, driving them here and there, roughly. Shiv said fantasising was the most they could do with him.

* * *

The following month they left the flat and moved south of the river, to a basement with bars on the windows. It was a dangerous and dirty area, noisy at night, keeping

them awake. There were fewer pupils, and it had been expensive to buy new furniture.

The awful thing – perhaps the thing, according to Shiv, which had driven Luna to her bed – was that Winnie had been asked out by the Billionaire. Not only that, after telling Luna this and completing the date, she refused to divulge a single thing about the Billionaire: whether she liked him, whether she was seeing him again. Not a word, a complete blackout, except that Winnie did go to Venice.

Shiv said that what mattered was that they didn't lose more students. The Billionaire continued to come for his lessons, Shiv pushing him to work on Howlin' Wolf. The Billionaire was making good progress, said Shiv, as the two of them sat there under the photograph of Jimmy Page. He really was smart.

The Billionaire mentioned that he wanted to start an amateur blues band with friends, to play charity gigs. He was wondering if Shiv would like to play guitar with them and produce the music. It would be a blast. Shiv said yes, and Luna would play piano for as long as she could, during her pregnancy.

Acknowledgements

'Birdy Num-Num' first appeared in *Sight & Sound*; 'If Their Lips Weren't Sealed by Fear' first appeared in *Antigone*, Slavoj Žižek (Bloomsbury, 2016); 'Love Is Always an Innovation' first appeared in *The Amorist*; 'Excessive, Explosive Enjoyment' first appeared in *Port* magazine and *la Repubblica*; 'London: Open City' first appeared in the *Financial Times*; 'Where Is Everybody?' first appeared in *L'Espresso* and *Vrij Nederland*; 'Two Keiths and the Wrong Piano' first appeared in *Granta*; 'It Feels Like a Crime: The Devil Inside' first appeared in the *Guardian*, *La Stampa* and the *Frankfurter Allgemeine Zeitung*; 'The Muse Gave Me a Kiss' first appeared in the *Guardian*; 'She Said He Said' first appeared in the *New Yorker*; 'We Are the Pollutants' first appeared in the *Guardian* and *la Repubblica*; 'It Was So Much Fun' first appeared in the *Guardian*; 'Starman Jones' first appeared in the *Guardian* and *la Repubblica*; 'His Father's Watch' first appeared as an afterword in *The Train*, Georges Simenon (Kampa Verlag, 2020); 'The Widow' first appeared in *Il Messaggero*; 'Travelling to Find Out' first appeared in the *London Review*

of Books; 'Why Should We Do What God Says?' first appeared in the *Times Literary Supplement*; 'Fanatics, Fundamentalists and Fascists' first appeared in the *Spectator* and *la Repubblica*; 'Nowhere' first appeared in *Zoetrope: All-Story* magazine; 'My Beautiful Box Set Binge' first appeared in the *Guardian*; 'An Ice Cream with Isabella' first appeared in *Corriere della Sera*.